Perthshire
MURDERS

Perthshire
MURDERS

Geoff Holder

AMBERLEY

Dedicated to all the victims of these crimes.

First published 2010

Amberley Publishing Plc
Cirencester Road, Chalford,
Stroud, Gloucestershire, GL6 8PE

www.amberley-books.com

Copyright © Geoff Holder 2010

The right of Geoff Holder to be identified as the Author
of this work has been asserted in accordance with the
Copyrights, Designs and Patents Act 1988.

ISBN 978 1 84868 072 2

British Library Cataloguing in Publication Data.
A catalogue record for this book is available from the
British Library.

Typeset in 10pt on 12pt Sabon.
Typesetting and Origination by FONTHILLDESIGN.
Printed in the UK.

CONTENTS

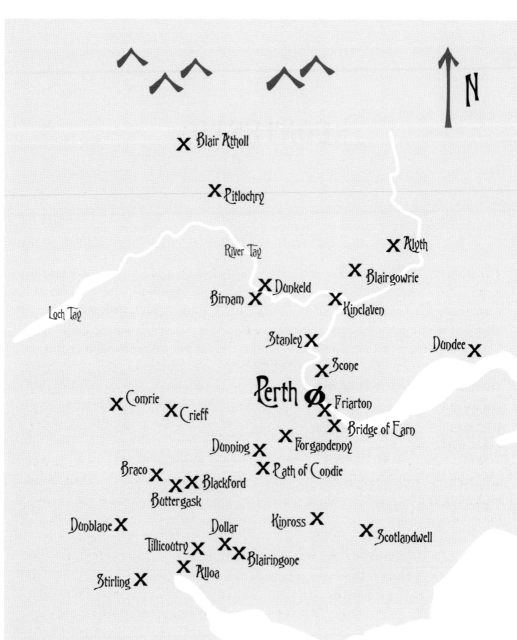

Map of Perthshire and surrounding areas, showing the places mentioned in the text.
(*Jenni Wilson*)

INTRODUCTION

"Murder…a crime of so deep and scarlet a dye."

Sir Walter Scott, 1795

There is a tendency – and a tendency that I admit to sharing – to find crimes from the past coated with a light dusting of romance. Perhaps influenced by endless costume dramas, we conjure up gas-lit images of fog-bound intrigue and excitingly darkened alleys, of nefarious muffler-clad footpads and dependable bewhiskered policeman. This attention to the period details, to the enticing attractions of clothes and hairstyles, buildings and horse-drawn carriages, master detectives and larger-than-life villains, can mislead us into 'soft' thinking. The passage of decades and centuries inevitably has a distancing effect. We tend to think, because the crimes were committed a long time ago, that they were somehow not as awful as the brutalities that daily stain our modern newspapers or digital media outlets.

Not so. The crimes in this book, which cover the period from 1795 to the 1880s, are just as horrible and vile as those familiar to us today. Skulls are crushed, limbs broken, flesh punctured by bullets, arteries severed and hideous injuries inflicted on the vulnerable. The tendency of some men to beat and kill their wives and children is not a modern phenomenon. Neither is crime committed for short-term gain, or out of selfishness or stupidity. Rape and sexual assault are never pretty, whatever the century. And murder – well, murder is never pretty.

The stories in this book deal with over a dozen murders and culpable homicides (the Scottish legal equivalent of the lesser charge of manslaughter). In some cases the perpetrator was punished; on other occasions they literally got away with murder. It is also possible that some of the alleged perpetrators suffered a miscarriage of justice – after reading the cases, you can be the judge of that. Also included are cases where criminals were hanged for crimes other than murder: the thugs who terrorised the people they assaulted and robbed generate little sympathy, but it is hard not to feel a pang of regret about Alexander Reid, hanged for stealing some sheep (see Chapter 6). The chapters proceed in a roughly chronological order, so it is possible to appreciate, for example, the improvement in the quality of police work and forensic examination

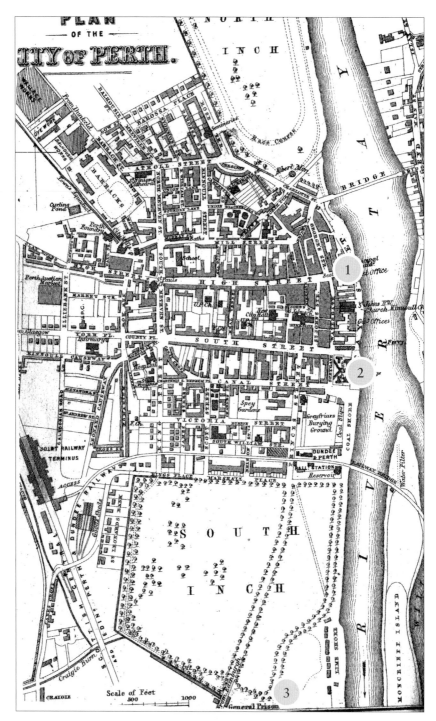

Perth in 1880. The 'Municipal Buildings' mark the site of the Old Tolbooth (1).
The Speygate Prison is shown behind the County Buildings (2), and the General
Prison at the very bottom (3). (Perth and Kinross Libraries)

between the murders of Elizabeth Low in 1818 and John Miller in 1869. The progression also allows you to notice how punishments and executions changed over the century.

To vary the diet of murders and executions, there is also a round up of the ghoulish exploits of the bodysnatchers, while Chapter 3 is devoted to tales from Perth's three prisons, including details of riots and disturbances and daring escape attempts. Chapter 9, meanwhile, features a number of varied tales of assault and arson, among them a group of whisky smugglers who almost beat an Excise officer to death (and then got an astonishingly lenient sentence), a gas-works manager who deliberately set fire to his own home, and a toff who thought his elevated status meant he could bully or beat anyone of a lower social class.

Serious crime in nineteenth-century Perthshire was rare, but because Perth was also a centre of justice, a few notes might be useful on the institutions and terms that crop up again and again in the proceeding chapters.

CIRCUIT AND SHERIFF COURTS

The supreme court in Scotland was (and still is) the *High Court of Justiciary*, based in Edinburgh. All cases involving murder, treason and counterfeiting, plus rape and other sex crimes, had to be heard in the High Court before a jury of fifteen (not twelve as in England). The Court also dealt with the more serious cases of theft, housebreaking and assault if the potential punishment included execution or transportation (see below). County-based *Sheriff Courts* were presided over by the Sheriff, the most senior law officer or judge in the county; Sheriff Courts generally dealt with less serious crimes than the High Court. The *Procurator-Fiscal*, an office mentioned several times in the following pages, is the Scottish term for a public prosecutor, with direct responsibility to the Sheriff Court.

As it was not practical for all serious cases to be brought to Edinburgh, High Court judges travelled on a circuit twice a year, bringing the High Court to Ayr, Jedburgh and Dumfries (the Southern Circuit), Glasgow, Inverary and Stirling (the Western Circuit), and Inverness, Aberdeen and Perth (the Northern Circuit). Most of the cases in this book were tried by these spring or autumn Circuit Courts, although some were heard in Edinburgh. The Perth sitting of the High Court also included cases from Fife, Dundee and Forfarshire, but this book only deals with crimes that were committed in Perthshire. (Please note that nineteenth-century Perthshire covered a much larger area than today's county of Perth and Kinross, and incorporated places such as Dunblane which are these days part of the modern Stirling District.)

One High Court judge, Lord Cockburn, left an entertaining and revealing memoir of his time on Circuit. Here, for example, is his entry for Perth on 30 April 1842:

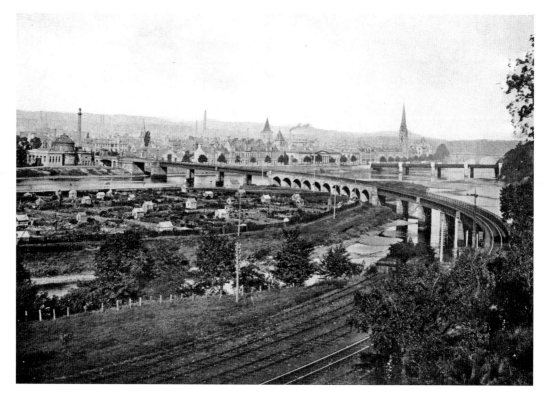

Perth from the southeast, around 1902. The Sheriff Court is the columned building between the two bridges. (Perth and Kinross Libraries)

We had eighty-four cases, the greatest number, I am told, that has ever been at any one Circuit town in Scotland…Nor was there any case worth recording, except one too horrid, however, to be mentioned. The dark roll was filled with the ordinary, and scarcely varied repetition of robberies, assaults, sheep and cattle stealing, fraud, conspiracy, forgery, fire-raising, night poaching, bigamy, and above all of theft, which now forms fully a half of all the criminal business of Scotland. There is certainly a fashion in crimes. There was far less transportation than usual, long imprisonments in the recently-opened penitentiary at Perth being the substitute.

EXECUTION, TRANSPORTATION AND PENAL SERVITUDE

The reason Lord Cockburn and his fellow Circuit Court judges were occupied with so many thieves, poachers and bigamists was that the High Court had the responsibility of dealing not only with serious *crimes* but also serious *punishments*. The Scottish legal system was distinct from that in England. Up until 1855 Scotland had twenty-five crimes that could attract the death sentence. Only one of those crimes was murder. In contrast to the situation south of the border, Scotland had no set scheme of recommended punishments. The sentence a felon received was decided by reference to precedent (that is, the nature of the punishment handed down for similar crimes in other recent cases), while the judge had immense discretion in deciding how lenient or severe he could be. If the judge took against the *panel* (the legal term for the accused), or was just having a bad day, the consequences could be harsh, even for relatively minor offences. By and large, cases early in the nineteenth century, when the legal code was more Draconian and bloodthirsty, were more likely to attract "the final punishment", as the death sentence was known.

The principal alternative to execution was *Transportation,* where the felon was sent into exile in a penal colony on one of the British overseas territories. Quite simply, Britain did not have enough prisons, and so the criminal population was exported. From the early seventeenth century the New World had been the transportation location of choice, but the American Revolution of 1776 put paid to that. A few alternatives such as the Falkland Islands were scouted, but it soon became clear that Australia offered the best choice. The first convicts were transported to the Antipodes in 1787, and transportation remained a significant system of punishment until the 1850s, finally being abolished in 1868. Any individual sentenced to seven or more years' imprisonment could be transported. Tariffs were usually seven years, fourteen years, or for life. For example, Donald McPherson, convicted in Perth of assault and attempted rape in 1831, was served with a warrant authorising him to be "transported beyond Seas, for and during the days of his natural life." From 1842

some Scottish transportation prisoners spent some time in Perth General Prison until their ship was ready.

Penal Servitude was introduced in 1853, and often replaced transportation. Prisoners remained in Britain but performed hard labour for the majority or entirety of their sentence.

SITES OF EXECUTION

Because the High Court sat at Perth the city had the right to perform executions. Before 1774, in common with most Scottish cities, the gallows had been well outside the city limits. In Perth the site had been way to the west on the Burghmuir, but this was increasingly unsatisfactory on several counts – the prisoner had to be taken on a long humiliating journey, which allowed the crowd to shout abuse or throw things at the cart; the return journey was often disorderly because the mob, aroused by the hanging, would now randomly attack the guard and the civic officials; and the entire process was time-consuming and expensive. A more orderly and efficient system was required. The simplest choice was to build the gallows immediately outside the prisoner's place of incarceration.

After 1774, the new execution site, therefore, was outside the Old Tolbooth at the eastern end of the High Street, beside the river. The usual scaffold erected here had a platform with a trapdoor; the condemned criminal stood on this with a noose around the neck. When the executioner pulled a lever the trapdoor opened and the prisoner dropped down. If the executioner had done his job properly the drop would cause the noose to break the neck, leading to almost instantaneous death. If there had been a miscalculation, the prisoner would slowly strangle to death on the end of the rope. George Penny's book *Traditions of Perth* recorded a variation of the standard theme: on one occasion there was no drop, but a heavy weight attached to a jointed beam holding the noose. When the weight fell, the beam abruptly rose, jerking the prisoner *upwards* off the scaffold. It was not a satisfactory operation.

Perth's execution sites changed as its prisons changed. From 1817 or thereabouts the new location was outside the south wall of the recently-constructed Speygate Jail, overlooking Greyfriars Cemetery. Several descriptions of public executions on this spot can be found in Chapters 5, 8 and 9. After 1868 executions were no longer held in public, and moved inside the walls of the fortress-like Perth General Prison beyond the South Inch. The execution of George Chalmers on this spot is described in Chapter 12.

A NOTE ON MONEY

It is notoriously difficult to directly convert sums of money from the past into their value today, especially as the nineteenth century saw several periods of inflation, and wages for working people were also *relatively* lower than they are today (that is, when comparing *wages* relative to *prices*, farm workers in Victorian times earned far less, and had much lower spending power, than their twenty-first-century equivalents). As a general guide, multiplying sums by a factor of 200 may give you a rough estimate for the earlier part of the century. So when Mr. Bruce was paid £5 10s to help break someone out of jail (see Chapter 3), his fee in contemporary terms would have been around £1,100. For the later nineteenth century, a multiplier of around 100 will approximate the modern sum. This means that when a reward of £50 was posted for the Braco Murder in 1869 (see Chapter 12), its value in our terms was around £5,000. All sums were of course pre-decimal, with 12 pennies (12d) making one shilling (1s), and 20 shillings making one pound. A guinea was £1 1s.

FURTHER READING

Many of the cases in *Perthshire Murders and Misdemeanours* were covered in the newspapers of the day, and a full list of these is given at the back of the book, along with other printed sources such as books, magazines and broadsides (pamphlets covering sensational issues and sold cheaply on the street.) Other details have been drawn from the documents kept in the Archives section at the A. K. Bell Library in Perth, or at the National Archives of Scotland in Edinburgh.

CHAPTER 1

MURDER FILE №1: MARGARET BOAG

The Dunning Murder (1818)

On 19 January 1824 forty-four-year-old Margaret Boag stood in the dock of the High Court in Edinburgh, charged with a murder that had taken place a full six years before. For over 12 hours the packed courtroom had watched as a parade of witnesses had searched their memories and offered time-battered and contradictory evidence. At 10.45pm the jury retired, and were back within fifteen minutes. The verdict on the murder? Not Proven. But there was a lesser charge, that of theft. And on that count, Margaret Boag was found unanimously guilty. She was sentenced to transportation for life.

'Not Proven' is a verdict unique to the Scottish legal system. It is definitely not the same as 'Not Guilty', and is the verdict the jury are directed to give if they consider that the Crown has not proven its case beyond reasonable doubt. It is sometimes – and perhaps with justification – interpreted as meaning 'we know you did it but we can't make the charge stick'. If Margaret Boag was not the principal actor in the murder, she was certainly an accessory, for the theft she was convicted of had taken place while the bloodied and battered corpse lay in the same room, its body heat slowly ebbing away. Before the trial she had been offered a full pardon if she confessed to the theft and named the actual murderer, but this plea bargain had not been taken up.

The murder victim was seventy-five-year-old Elizabeth Low, one of the several tenants in the big multi-occupancy house in the Strathearn village of Dunning where Margaret lived with her father and brother. Elizabeth was last seen alive on the evening of Monday 16 February 1818. Between 7 and 8am on Wednesday her upstairs neighbour Charlotte Duncan noticed Elizabeth's door was slightly open. Calling and receiving no reply, she went into the darkened room, noticing the window shutter next to the bed was closed, which was not Mrs. Low's usual practice. The old woman usually kept a fire going in winter, but the room was unusually cold.

The opened shutter revealed a scene of horror. Lizzie Low lay face down on the floor, fully clothed and wrapped in a bed cover. Several layers of carpet were pulled tightly around her head. Her skull was fractured. A hatchet lay next to the body.

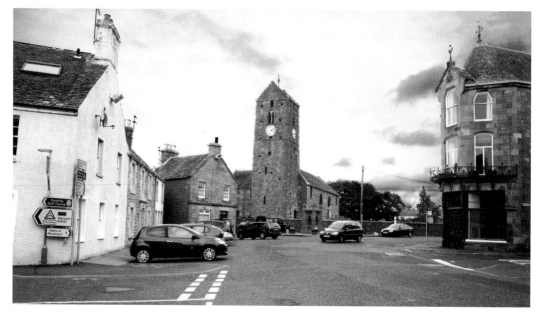

The village of Dunning, with the medieval tower of St Serf's Church in the centre. (The Author)

Commercial Buildings on Auchterarder Road, Dunning – the best guess for the location of the murder of Elizabeth Low. (Ségolène Dupuy)

Medical examination found a head wound three inches long, a blunt-force trauma that matched the rear of a hatchet. The face was blackened and the eyes and tongue protruded, and blood had congealed into a dark spread under the skin of the chest area. The body was cold, and there was no indication that a fire had burned in the grate for at least twenty-four hours. Elizabeth Low, it seemed, had been brutally attacked on Monday night or Tuesday morning. Either she had been overpowered and the carpet wrapped around her head to muffle any screams before the hatchet struck the killing blow, or, as seemed more likely, she had been bludgeoned first, but had not died instantly. The murderer then wrapped the thick layers of carpet around the mouth and head to ensure her dying groans were not heard. The clavicle had been dislocated after or just before death, probably while the carpet was applied.

No-one, however, appeared to have heard a struggle, although one of the house's multiple occupants noticed a sound 'like a stool falling'. But in the six years that had passed since the crime, several key people had died. And the initial police investigation had been poorly conducted, with few clear witness statements. When the same witnesses appeared in court, they were struggling to recall the exact sequence of events that took place from the Monday to the Wednesday all those years ago.

At some point James Dewar had been charged with the murder, but he was later released. There was no alternative suspect, and even a posted reward of 30 guineas – a substantial sum in those days – failed to produce any leads. The case went cold. But then in 1823 Margaret Boag offered to sell a tablecloth – an item that several people recalled belonging to Elizabeth Low. The authorities were informed and Margaret, along with her brother William, were arrested in Dunning and lodged in the Speygate jail at Perth. Many other articles belonging to Low were found in Margaret's room, and extensive interviews soon turned up a number of witnesses who had seen Margaret possess or sell many items that had belonged to the murdered woman. At some point William was released as no longer a suspect, and the burden of evidence fell solely on Margaret.

In 1818, Margaret Boag and her father John Boag lived on the ground floor of the five-storey building. Sometimes they were joined by her brother William Boag, also known as William Boug (the newspapers sometimes mistakenly gave the family surname as Boug or Bong). James McLaren and his wife lived in an apartment on the other side of the passage. Elizabeth Low and Elizabeth Hunter each had a room on the first floor, with Charlotte Duncan above them, Janet Duncan on the floor above that, and finally William Drummond and his wife Mary on the top floor. Many other neighbours knew the apartments well. There was bad blood between Lizzie Low and the Drummonds, and in her deposition Margaret Boag specifically put the blame for the murder on William and Mary Drummond, but without offering any evidence. As no Drummonds appeared in court, it appeared the family were no longer in the land of the living.

The accounts of the time do not mention the exact address, but the Dunning Parish Historical Society have a 'best guess' candidate – Commercial Buildings, on the north side of Auchterarder Road. It has (or had) four storeys, not five, but perhaps a 'semi-storey' or stair junction apartment was counted as a separate floor.

The Crown's case for the murder charge was entirely circumstantial, and a bit shaky. Late on Monday night a light was seen in Elizabeth Low's room, but the window was shuttered, which was unusual, and a friend had had no reply when she had come calling at 8pm. It was established that footsteps had been heard going up to Elizabeth Low's apartment on Monday night, and coming down again. More noises were heard on Tuesday night. The footsteps had not reached as far as the Drummonds' floor. Margaret Boag had a door from her room leading onto the common stair, so she could have come and gone without passing through her father's room. She was not in her room on the night in question, and claimed to be with Peter Dow from Madderty. But her alibi was not supported. When the body was first discovered, several neighbours crowded into the apartment, and Janet Mudie spotted a pair of Margaret's footwear, exclaiming "God bless me, how came your slippers here!" Margaret gave an excuse that Lizzie had borrowed them on Monday night because she had been outside, gotten her own shoes wet, and dried her feet in Margaret's room. Yet at the time of her death on Monday Elizabeth Low was wearing her worsted stockings and leather shoes, tied twice around the ankles. The stout footwear would not have had a problem with the rain. Slippers, of course, make far less noise on stairs than ordinary shoes. At the time, however, Margaret's explanation was accepted without suspicion.

In fact, the charge of murder really rested on the evidence for theft, and here the Crown was on steadier ground. Janet Mudie and the other women had looked for something to wrap the body in. It was known Mrs. Low kept a chest filled with blankets, linen and ticking (a strong material used to cover mattresses and pillows), but it was locked. Margaret, however, knew that the key was under the bed bolster, which was where the old woman put it for safety when she retired for the night. As far as Janet Duncan knew, Margaret had never seen Lizzie Low go to bed, so how did she know the location of the key? When the chest was opened, it and an adjacent clothes press were entirely empty. At the time such textile items were probably the most expensive things an ordinary person would own, and they often formed part of a woman's dowry or inheritance. The size and number of articles would have required at least several trips up and down the stairs, so the theft would have been a long process possibly extending into the Tuesday.

A long parade of witnesses then testified that they had either seen Margaret with the dead woman's clothes, ticking or linen, or that they had bought such items from her (some of these witnesses clearly knew they were buying stolen goods, and had to be assured by the judge that they could not be prosecuted for the testimony they were about to give). Low's daughter Margaret McLaren testified that her mother had told

her she would inherit many of these items, and so had embroidered the initials 'M M' in the corner. Examples produced in court showed that the second 'M' had been picked out and replaced with a 'B' for Boag. Other clothes were identified by the weavers or seamstresses who had made them. Another neighbour recognised Low's kettle, basket and nightcap in Margaret's possession. When challenged on several occasions, Margaret swore she had been given the items by her relatives or had obtained them in exchange from other people, the story varying depending on when and to whom she was telling it. For one item she told five different stories. In her official deposition Margaret claimed the linen, blankets and so on had belonged to her (now deceased) mother, or she had found them hidden under wood in a lumber room behind Elizabeth Low's apartment. Unfortunately for these spiraling lies, the lumber room had been searched twice by police constables shortly after the murder.

The strangest evidence came from William Cree. He claimed that on the Tuesday night he saw the pregnant figure of Margaret Boag come out of Low's apartment carrying a large bundle. Despite then being the servant of Constable Robert Hastie, who was actively engaged in trying to solve the murder, Cree told no-one about this sighting for six years, only 'remembering' it about four weeks before the trial, when the question of the reward resurfaced. Cree did not come over as a credible witness, and was questioned closely about whether he had accepted money to appear in court. He admitted that Michael Oswald, the brother of Margaret Oswald, had suggested that his sister would pay his travelling expenses to Edinburgh. Now, Margaret Oswald was the wife of William Boag, who had initially been arrested on suspicion of the crime and then released. Was Margaret trying to ensure that her husband remained free of suspicion, ensuring that the focus remained on the already-compromised Margaret? Was some kind of neighbourhood or family dispute going on behind the scenes? Or were the Oswalds simply offering to help a poor man who needed to get to Edinburgh?

It is certain that Margaret Boag did, as the charge alleged, "wickedly and feloniously steal, and theftuously carry away a large quantity of linen in webs and sheets, and other articles of napery, a web of ticking, a number of pairs of blankets, etc." And that she did this while Elizabeth Low's dead body lay just a few yards away, so at the very least she was an accessory to murder. But did she actually "wickedly and feloniously attack and assault and murder" the old woman? At the time she was seven and a half months pregnant. Lizzie Low was old and frail, but was much larger than Margaret. Margaret had no history of violence or animosity against Low. No argument or raised voices were heard. Did Margaret raise the hatchet while the old woman's back was turned, and commit cold-blooded murder? She had the opportunity, but what about the motive? Perhaps her circumstances had put pressure on her. She was the widow of flax dresser John McLaren, and pregnant with the child of Peter Dow. Was Dow unwilling to financially provide for his offspring? Was she facing a slide into middle-

aged single-parent poverty? Sadly, nothing in the facts of the case help throw light on these issues.

The defence called two witnesses who testified that they had seen Mary Drummond leave the house carrying one or more bundles between 11 and 12pm on Tuesday night. The inference was that Mary was the murderer and thief. But one of the reasons the Drummonds were unpopular was that their whisky-smuggling activities meant they were tramping up and down the stairs at all hours of the night. Mary could have been involved in the Lizzie Low crime. Or she could have been simply carrying something associated with her illicit trade.

A newspaper account of the trial described Margaret as a small "country-looking woman", with "rather an unprepossessing cast of countenance…she did not seem much oppressed by a sense of her situation." At the time most thieves received seven or fourteen years' transportation. The severity of Margaret's sentence – transportation for life – implies the judges thought she was guilty of the murder; the Not Proven verdict saved her from the scaffold, but she was to be punished to the maximum the law allowed. In October 1824 she had an all-expenses-paid trip on the brig *Henry* to Van Diemen's Land, as Tasmania was then known, arriving in February 1825. Her six-year-old son William, born a month and a half after the murder of Elizabeth Low, remained in Scotland.

Given that Margaret Boag was only convicted of theft, the murder of Elizabeth Low remains technically an open case. It is one of the oldest unsolved murders in Scotland.

CHAPTER 2

MURDER FILE №2: DUNCAN CLARK

Baby Murder in the High Street (1825)

Duncan Clark was a professional man, a writer, that is, the person who laboriously wrote out by hand all the endless legal documents required by the Sheriff and Circuit Courts, such as precognitions, depositions, warrants and so on. He was a kind of solicitor. He lived close to his work, in an upstairs flat in the High Street. It is therefore ironic that on 20 September 1826 this man of the law should find himself the subject of a document written by another writer to the Court. It was headed "*Death Warrant of Duncan Clark*".

The warrant specified that he was "to be carried from the Bar back to the Tolbooth of Perth, therein to be detained and to be fed upon bread and water only." Further, on Friday 3 November 1826 he was "to be taken furth from the said Tolbooth to the common place of execution…and then and there betwixt the hours of two and four in the afternoon, to be hanged by the neck upon a Gibbet by the hands of the Common Executioner until he be dead." His body was to be handed to the anatomists at Edinburgh University and used for the purposes of dissection and education. As it turned out, Duncan Clark's fate was to be very different, if just as grim.

One of the fascinations and frustrations of reading old court and newspaper documents is what they leave out. How did Duncan Clark, professional urban dweller, come to father a child on Christian Cameron, an illiterate Gaelic-speaker who lived in Earls Dykes, off Glasgow Road outside the western edge of the city? The records are silent. But whatever the nature of their relationship, it was not a lasting one. In the early hours of Saturday 22 October 1825 Christian gave birth to a little girl. Once the infant had been cleaned, wrapped in swaddling clothes, and given the standard draft of low-alcohol punch, the mother handed the child to the attendants at the birth, and instructed them to take the baby away, and leave it with the father.

Ann Cameron, Isabel Cameron, and Christian's teenage daughter Margaret McNab consequently walked into Perth and about 7am arrived at Clark's dwelling, which was in a close and up a stair at the eastern end of the High Street. When the three

> and adjudged the said Duncan Clark, Pannel, To be carried from the Bar back to the Tolbooth of Perth, therein to be detained, and to be fed upon bread and water only, in terms of the Act of Parliament made in the Twenty fifth year of the Reign of his Majesty King Geage the Second, entituled "An act for preventing the horrid Crime of Murder"

Extract from the Death Warrant for Duncan Clark, ordering him to be fed on bread and water under the terms of "An Act for preventing the horrid Crime of Murder". (Perth and Kinross Council Archives)

> And there, by the hands of the Common Executioner, to be hanged by the neck upon a Gibbet, until he be dead, And ordained his body thereafter to be delivered to the Professor of Anatomy in the University of Edinburgh to be by him publickly dissected and anatomized

Extract from Clark's Death Warrant, ordering his body to be publicly dissected in Edinburgh after his execution. (Perth and Kinross Council Archives)

women arrived they found Clark in his writing-room. He was shocked to see the baby and insisted they take it away. The women refused and told him the baby was his responsibility and he would have to find a nurse to look after it.

Clark now seemed both angry and resigned. He left the house several times in search of a nurse, at one point asking a woman named Mary Robertson to take temporary charge of the child until 7pm. The story he told her was that it was a gentleman's child which later that night would be going to Bridge of Earn to be placed in the care of a nurse engaged two weeks previously, but who had yet to arrive. This was the first of many lies that Duncan told that day, and seems to indicate he was in a state of panic,

Perth. The view from Tay Street onto the eastern end of High Street, home of Duncan Clark. The pre-1819 execution site was near here. (The Author)

making stories up whenever he was faced a difficult question or a new player in the drama. Mary Robertson said she did not have the capacity to look after a baby that day, although when Clark returned home he told the three women he had engaged her. The child was never brought to Ms Robertson.

Clark then persuaded the three women to leave, saying all arrangements had been made. Obviously suspicious, they simply moved to an apartment tenanted by a Mrs McLeod at the bottom of the stair, and kept an eye out for the nurse. They saw Clark leave and return several times, but no nurse appeared. Eventually Margaret McNab returned to the writer's rooms to check on the child. But the baby was nowhere to be seen. Clark said he had sent the infant away to be looked after by a nurse in Bridgend, and invited Margaret to look through the entire apartment as proof. Margaret came down the stairs in great distress, and told the other two women she feared the baby was dead.

The three women rushed into the street and collared a stranger, saying "Mr. Clark has murdered a baby." The man, James Halley, went up the stairs and found nothing. Clark gave him the address of the nurse in Bridgend, so Mr. Halley, Ann Cameron and a hastily summoned town officer named David Garrick set off across Perth Bridge to

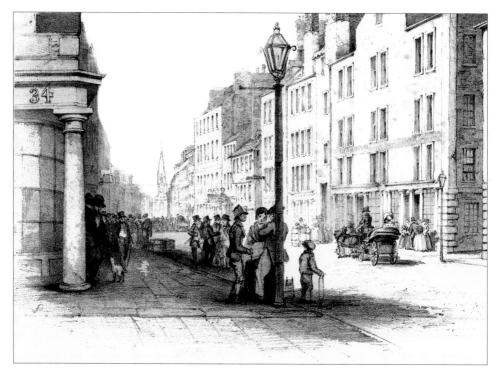

Perth High Street in the mid nineteenth century. (Perth and Kinross Libraries)

High Street in 2010. Some of the same buildings remain. (The Author)

the suburb lying on the opposite side of the Tay. They could find no trace of either nurse or child, and so returned to Perth.

Duncan Clark now seemed to be set on a bizarre course of making up fantastical excuses that he knew could not be substantiated, all based around this story he had concocted of a nurse in Bridgend. Garrick and Halley pressed him again about the child, so he took them to Jackson's pub in Bridgend, bought them a drink, and told them to wait while he went to bring the woman and child. Some time later he returned alone, saying the nurse would not come because she was afraid of the town sergeant. Halley then volunteered to go with Clark to see the woman, but a few minutes later he came back to the pub and said to Garrick, "This is all a joke, for there is no child belonging to him here." The now deeply suspicious Garrick detained Clark and took him to the Procurator-Fiscal. Twice Clark described where the child was kept, and so the Sheriff's men made another two entirely fruitless trips to Bridgend. Clark knew that his bogus tales could not be verified; but presumably he hoped that, in the absence of a dead body, he might still have a chance of freedom.

Indeed, although the authorities knew the baby was not in Bridgend, they could not actually find it. On Sunday, the day after all the to-ing and fro-ing, Clark's apartment

A view of Perth from Bridgend around 1902. Duncan Clark and the authorities crossed Perth Bridge several times on the day of the murder. (Perth and Kinross Libraries)

was thoroughly searched, with no result. The three women had not seen Clark or anyone else leave with anything baby-sized, so where was the child?

The house was searched for a second time on the Monday. During this search a horrible thought occurred to the police officers: the only place in the entire set of rooms that had not been looked into was a locked escritoire or writing-desk. Blacksmith George Garvie was sent for, and he picked the lock. The roll-top lid was opened. Within was the dead body of the little girl.

Duncan Clark was originally due to be tried in April 1826 but an argument over a legal technicality delayed the trial until the Autumn Circuit. On 20 September 1826 he stood in his former place of employment, the Perth Circuit Court, in the unfamiliar situation as the prisoner at the Bar. In answer to the charge of "wickedly, barbarously, and feloniously" murdering a female child, he answered 'Not Guilty".

Ann Cameron, Isabel Cameron and Margaret McNab all gave evidence in Gaelic, informal translation being provided by General Stewart of Garth. One of the unexplained aspects of this case revolves around the language issue: were the three women monoglot Gaelic speakers, meaning Clark and James Halley must have spoken to them in Gaelic? Or did they know enough English to get by, but for some reason maintained in court that they could only understand their native tongue? The other curiosity was that Christian Cameron, the child's mother, was not called as a witness.

A great deal of time was taken over the medical evidence. Had the child been placed alive in the escritoire, and then simply suffocated? Or had she been first smothered with blankets? Or choked? Or even had the skull compressed or crushed? Or could she have just died of natural causes prompted by her newborn condition and lack of food and proper care on the journey from the birth-bed into Perth? Had the actions of her mother or the three guardians brought about the death? The medical witnesses disagreed among themselves. Given the embryonic state of forensic medicine at the time, and the fact that the victim was neonatal, perhaps the most sensible comment came from a witness called by the defence, Dr Christison, the Professor of Medical Jurisprudence at Edinburgh, who stated, "It was quite beyond the reach of medical skill positively to ascertain from these appearances whether the death was natural or proceeded by violence." It was clear the evidence could not show whether Clark had deliberately killed the child, damaged it accidentally through not being familiar with the fragility of newborns, or just locked it away in the hope that after a time he could offload the baby onto a nurse or institution, and hence be legally rid of his new responsibility. If the death was not deliberate, he could have been found guilty of a lesser offence, culpable homicide.

The jury of fifteen men retired at 10.30pm. They returned within a quarter of an hour. By a majority of just one vote (eight against seven) Duncan Clark was found guilty, with a unanimous recommendation of mercy. On hearing the sentence Clark, who had spent the entire trial staring downwards, fainted and fell down at the Bar. He had to be assisted from the court.

Three petitions for clemency were soon in circulation. One was from Clark himself; the second from a large number of respectable and professional people in and around Perth; and the third was signed by every member of the jury. All three were based on the circumstantial and uncertain evidence in the case, while the one from the jury expressly maintained that the eight who had voted for a Guilty verdict had admitted the evidence was difficult and contradictory.

On 18 October 1826 the Perth authorities received a letter from Whitehall stating that Prime Minister Robert Peel had advised King George IV to commute the sentence of Duncan Clark to transportation for life. On hearing the decision, Clark exclaimed "God bless His Majesty and Mr. Peel!" The same post included a similar reprieve for Robert Lacky or Locky, who had been condemned to death at the same court session, his crime being housebreaking in Fife. Locky had received the sentence of death with equanimity, and listened to the declaration that saved him from the gallows with equal calmness. Throughout his time in court and in custody, Locky rarely rose above an expression of boredom or indifference.

Clark was sentenced to spend the rest of his natural life at the Australian penal colony of Van Diemen's Land (Tasmania). As was commonplace, he was taken to the south of England before his departure and kept on one of the Hulks on the River Thames. The Hulks were large ships converted to floating prisons, where prisoners were kept in appalling conditions, rife with disease and neglect.

In March 1827 it was reported that Duncan Clark, former writer in Perth, had died on board one of the Hulks.

As a coda to this sad tale of two sad deaths, it is worth pointing out that the prosecution of a man for the killing of a newborn was rare. The Perth court archives of the nineteenth century are awash with dismal tales of neonatal death. The story was almost always the same: the father was nowhere to be found; the mother was unmarried and from the lower strata of society; if the pregnancy and birth were discovered, the woman would lose her job or dwelling, or be cast out by her family. Some women actively killed their newborn baby; others failed to keep it alive because they were sick, scared, desperate, unconscious after the birth, light-headed through loss of blood, ignorant of what to do, unable to give milk, or mentally ill. A charge of murder was rarely proved, the usual case being culpable homicide. Even that charge had a low conviction rate, although the crime (!) of 'concealment of a pregnancy' was more easily proven. The cases have a grim stereotyped quality about them, and throw a bitter and pitiless light on the awful experience of poor women in the nineteenth century.

CHAPTER 3

PRISON TALES

Perth had three different prisons during the nineteenth century, and the contrast between them could not be greater. The oldest was the Tolbooth, which stood at the east end of High Street, beside the river. Nothing now remains of this building, which was originally erected in the 1690s. The raggedy Tolbooth was replaced around 1819 by the purpose-built Speygate Prison, constructed behind the new County Buildings and Sheriff Court a few hundred yards south of the High Street. This lasted, at least as a structure if not a prison, until 1968, when it was demolished to make way for a car park (the former prison yard had for some time been used as a storage depot by the Council's Water Department). The third place of incarceration was the General Prison, which came into use from 1842 as a secure place for prisoners from all over Scotland serving longer sentences. (Thirty years previously the site had been used as a huge prisoner-of-war camp, the Perth Depot). The massive quasi-medieval fortress of Her Majesty's Prison Perth still looms above the southern part of the city, and is the oldest prison in Scotland still in use.

THE TOLBOOTH

This formed part of the Old Council House, a rambling edifice dating from 1696 that once completely blocked the eastern end of High Street, where the various Perth and Kinross Council buildings now occupy both sides of the road at the junction with Tay Street. The Old Council House had a series of arches or pends facing the river which could be sealed off in periods of danger (for centuries the river was the main highway to Perth). As times changed the building was simply in the way, preventing easy access to the river and the new swanky thoroughfare of Tay Street. After being replaced by the new and expensive County Buildings (on Tay Street) in 1819, the Old Council House simply fell into disuse, and was finally demolished in 1839.

The Old Tolbooth and Council House that once blocked the eastern end of High Street. One of the defensible pends is shown to the right. (Perth and Kinross Libraries)

The same view in 2010. The removal of the Tolbooth opened up High Street and made Tay Street possible. (The Author)

As a jail the Tolbooth was entirely inadequate. The cells were cold, dirty and insecure. Prisoners could easily communicate with people in the street. Men and women, dangerous criminals and civil debtors were incarcerated together. On the afternoon of Sunday 23 March 1817 John Hughes (imprisoned on a charge of forgery), aided by James Ferney (stealing cattle), James Gillespie (housebreaking), James Miller (theft), and James Stewart alias Galletley (street robbery) wrenched a large iron bar from the door of their cell and started to hack through the stonework in the back wall of the prison. The escape site was cunningly chosen, as the operation was masked by the oil-house facing the river. The wall had been penetrated more than half way through before jailor John Simpson discovered the attempt, and with the guard stopped the prisoners. This episode was typical of the way the Tolbooth fell below the minimum security standards. Galletley was in trouble again eighteen years later in August 1835 when he was convicted for attempting to suffocate a woman.

THE SPEYGATE PRISON

The new County Buildings, Courtrooms and Jail cost £32,000, and opened in stages, the main courtroom and prison being operational from late 1817. The river-facing Neo-Classical structure, now the Sheriff Court, still dominates lower Tay Street and anyone can attend trials. Behind the County Buildings and facing onto Speygate rose the new Jail. *The Guide to the City and County of Perth*, published in 1822, boastfully listed its state-of-the-art features: "Two Prison-houses, the northern for Felons, the other for Debtors; in both the rooms are clean and well aired, and each is surrounded by an area, which is separated from the Court-yard by Soldiers' Guard-rooms, Turnkey's Lodgings, and Lock-up Cells for Vagrants. From the Jailor's House, which fronts the gate, there is a private passage under-ground leading to the Prisoners' Box in the Justiciary Hall." A subterranean passage still connects the Court's temporary cells and the Prisoners' Box in the imposing Courtroom One.

Not everyone was so impressed with municipal Perth's sparkly new landmark. Prison inspectors in the 1830s consistently found the twenty-nine cells overcrowded, dirty, insecure, and lacking light and air. "Very little good effect can be produced by imprisonment in the Perth jail," said one report. There was no attempt at reforming behaviour, and the punishment system was weak. Prisoners could easily communicate with the outside world. There was no discipline, no work for the prisoners, no structured daily routine, no moral or religious instruction and no female staff for the women prisoners. Many prisoners were repeat visitors, with two women having been imprisoned more than twenty times apiece. The jailor and turnkey both lived on the premises. In 1834 one of the prisoners sent a letter to the Town Baillie complaining

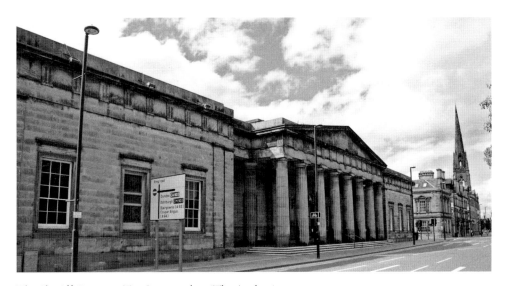

The Sheriff Court on Tay Street today. (The Author)

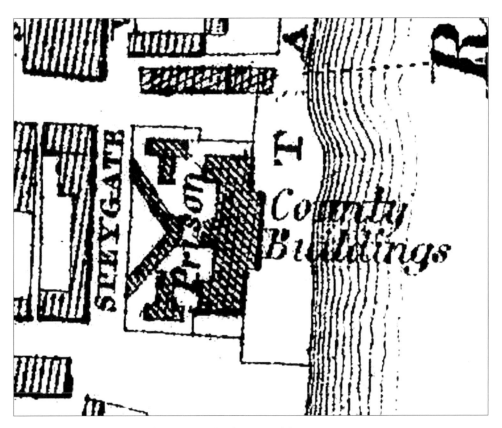

The County Buildings, clearly showing the division of the Speygate Prison into two parts. (Perth and Kinross Libraries)

about the turnkey. This official was charged with stealing articles from the prisoners, underpaying them for other things, getting drunk and hitting a prisoner. The turnkey admitted these offences and was dismissed, which meant he also lost his home. He asked the Council to be reinstated but they refused his appeal.

Disruptive behaviour was commonplace. One prison report described the enactment of a favourite entertainment called a 'Hell Scene': "Having assembled in the day-room, and provided a plentiful supply of water, they put out the candles, and then, amidst shouts and yells, and other discordant noises, and uttering revolting exclamations, they pull the fire to pieces, and fling the live coals round in every direction; others, at the same time, dashing water about, and in every way creating uproar and confusion."

Probably the biggest headache was security. In 1817 George McMillan escaped before his trial on a charge of stouthrief, thus avoiding the death penalty handed down to his associate Malcolm Clark (see Chapter 6). The incident was deeply embarrassing for Perth Council, and the Lord Provost found himself called before the court to explain how a prisoner on a serious charge had slipped out of a brand-new jail. According to the *Perthshire Courier* of 25 September, the Lord Provost waffled and floundered, stating "the accident had arisen chiefly from the difficulty of all at once, attending minutely to the weak part of so extensive a building, and that the Magistrates by offering rewards and otherwise, had done all that lay in their power to arrest the flight of the criminal." In other words, it wasnae their fault, honest. When the Circuit Court rose at the end of its Autumn Session, the Lord Justice Clerk finished the day by congratulating the city on its new courthouse and jail, then pointedly remarked that the proper security of some parts needed looking into to avoid further escapes. He also dropped a not-altogether-subtle warning about the trustworthiness and diligence of turnkeys, the management and moral guidance required for the running of a modern jail, and the need to exclude alcohol. One can imagine the Magistrates and Lord Provost feeling like country cousins, being lectured by the smart boys from the big city. But then, they had let a dangerous felon abscond from their latest source of civic pride.

In 1824 a Perth-based businessman, in custody for perjury or fraudulent bankruptcy, was keen to entirely avoid the irksome difficulties of incarceration. So when one of his fellow jailbirds, a Mr. Bruce, was released on a lesser charge, he found he had been given a helping hand back into society, in the shape of an advance of ten shillings. If Bruce kept his part of the bargain he would stand to gain a further £5. Bruce bought a saw and other items designed to gag and pinion the jailor and his assistants, then climbed the outside wall of the prison and placed them in a prearranged spot. Another prisoner picked the bag up and secreted himself in a trough overnight. He then partly cut through the padlock on the second outer door. Unfortunately for the escape attempt the jailor found the compromised padlock, quickly secured the door with two other locks, and informed the Magistrates.

When they realised that a mass break-out had only narrowly been prevented, the authorities ordered the prisoners into their cells twenty-three hours a day and closed access to the day-room. This regime continued for four days until a number of men refused to return to the cells after breakfast. A hard core of eight prisoners kept jailors, Magistrates and police officers at bay with knives, razors and other weapons such as bricks torn from the back of the chimney and placed in small bags and whirled round – a blow from one of those could break an arm. One prisoner from Dundee declared that he would die rather than go back, as he knew he would be hanged at the next Circuit Court anyway. The stand-off continued until a party of dragoons under Lieutenant Rose arrived from the army barracks on Barracks Street, on the road to Dunkeld. With a phalanx of rifles pointed at them, the rioters threw down their arms and surrendered.

Several murderers were executed outside the south wall of the prison, and their tales are told later in this book. Up until the early twentieth century their names could be seen inscribed on the prison wall, accompanied by a skull and crossed bones, plus the words of chapter 9, verse 6 from the Biblical Book of Genesis: "Whoso sheddeth man's blood, by man shall his blood be shed."

THE 'FRENCH PRISON'

Between 1810 and 1812, at the height of the Napoleonic Wars, a prisoner of war camp was set up at the edge of the South Inch. 7000 Frenchmen, guarded by 300 soldiers, lived in a massive stone-built edifice constructed at a staggering cost of £130,000. At this date most British prisons were dreadful hovels run as cheaply as possible, so why was this vast expense justified? The answer is one that echoes down the centuries to our present day: ostensibly cash-strapped governments can always find money in times of war. Vast numbers of POWs were being captured: national prestige demanded the raising of standards for the incarceration of foreigners. Hence large sums of money were quickly authorised for the building of impressive structures such as the Perth Depot, and the prisons themselves were very speedily built.

Many of the POWs were disembarked at Tayport and marched from there to Perth. A fair number of them died at the Depot and when new walls were constructed for the prison in the 1970s, skeletons were discovered, and a plaque erected to their memory. Although the prison was thoroughly redeveloped later in the nineteenth century, some of the architecture of the POW camp still survives in the present prison, including the perimeter wall and canal (or moat), the former Governor's House at 5 North Square and the guardhouses flanking the main entrance fronting Edinburgh Road. The French prisoners were given a degree of flexibility in their incarceration, and became popular with the people of Perth. The Frenchmen sold dolls, dominoes, ornaments and other

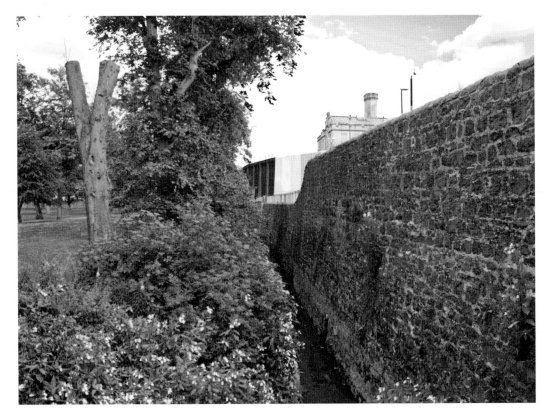

A relic of the French Prison of 1812 – the moat along the north wall of Perth Prison. (The Author)

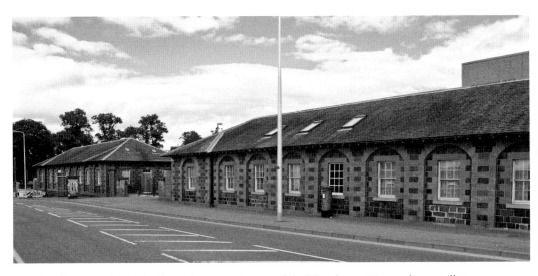

Another reminder of the depot for the prisoners of the Napoleonic Wars – the guardhouses fronting Edinburgh Road. (The Author)

objects beautifully crafted from bone or modelled in clay dug out of the prison yard (some are kept by Perth Museum). They earned money teaching languages, music, dancing or art. Others painted portraits or put on puppet shows. Officers were given parole and allowed to live outside the prison, paying for their accommodation and food from their private incomes. Many officers broke parole and tried to escape the country – those that were recaptured were sent back to the Depot, where they paid the more humble prisoners 3d a day to be their servants.

The French prisoners started to go home in June 1814, after what was (falsely) believed to be the final defeat of Napoleon. Many sailed down the Tay, to the loud cheers of spectators, while others marched to Newburgh for embarkation. Their departure had a major financial impact on the area. The Depot then lay empty, with the occasional use as a granary. It was an expensive bit of real estate without any obvious function. At the time the Scots had few long-term prisoners, as most felons were transported to Australia. But by the mid-century transportation was starting to fall out of favour, and the 'French Prison' had a new lease of life.

THE GENERAL PRISON

Throughout the 1830s changes had been afoot in the Scottish prison system. A series of inspections had found the mishmash of town, city and county jails to be often badly run, insecure, insanitary and even corrupt. Recommendations were put forward for a penitentiary system, where all prisoners serving long sentences (say, more than nine months) were to be kept in the same secure place. Perth, with the existing acreage, walls and moat of the French Prison, was the obvious choice. The new regime was also designed to assist in reforming at least some criminals. All prisoners were to work, and to learn a trade to allow them to earn an honest living. Educational, moral and religious instruction was to be provided. Female and male prisoners were to be kept separate, with the former being guarded by female warders. Work on the new General Prison commenced in 1840, with the building of new wings and exercise yards. Two years later it was open for business, with 535 prisoners in its first year. More cellblocks were added over the years and by 1881 there were 884 felons in residence in 580 ordinary cells, 16 punishment cells, and 108 female cells. For many years, before the building of Peterhead jail, Perth was the only General Prison in Scotland. In April 1842 Lord Cockburn visited the prison when he was on the bench at the Perth Circuit Court, and described the establishment as "a very humane and well-considered experiment....The prison is in beautiful order." The administration included a Governor, depute-governor, Matron, male and female warders, teachers, trades instructors, scripture readers, and a resident chaplain, medical officer and nurses. Compared to the Speygate Prison, it was a new world.

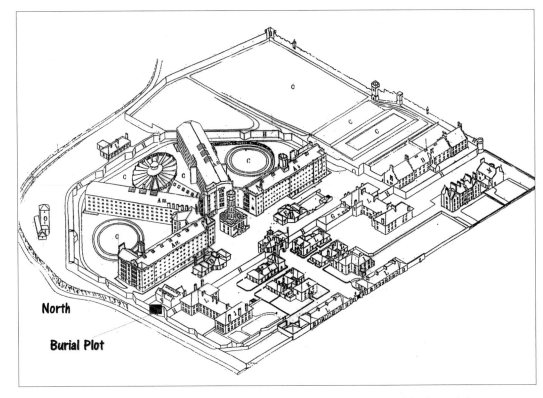

North

Burial Plot

Plan of Perth General Prison, showing the radial nature of the four main blocks, and the circular exercise yards. The Lunatic Department was the row marked 'B' to the right. The Burial Plot was where executed criminals were interred. (Courtesy of Wayne Stevenson)

That didn't prevent problems, of course. The Governors' Journals for 1845-55 and 1862-65 paint a depressing picture. Many convicts sentenced to transportation were sent here before departure overseas – this 'probationary period' could last from twelve to eighteen months, and was often spent in solitary confinement. The poor diet, grim labour, harsh punishments and the horror of solitary confinement encouraged illness, disease, suicide and mental collapse. Babies were stillborn, or died within the week, or, rarely, survived for a year, after which they were taken away from their mothers and 'sent out' to relatives or for adoption. Prisoners assaulted teachers, warders and each other, being punished accordingly. Swearing, smashing cell furniture in frustration and refusing to work earned more punishments, with many prisoners thus spending most of the day in handcuffs and leg-irons. There were endless suicides, most found in the under-twenty-five population, for whom the silence and loneliness of solitary confinement proved intolerable. Those who did not try to kill themselves frequently lost their minds, and there was an endless parade of unfortunates being taken from the ordinary cells to the Lunatic Department. In August 1852 a nineteen-year-old prisoner

awaiting transportation was found dead in his bed; it seems likely he was in a state of depression, and after a long and slow mental and physical decline simply gave up the will to live.

On the staff side there were problems too. Many warders were dismissed for drunkenness, unpunctuality or falling asleep at their posts. Others resigned because they found the work too hard, their bosses too overbearing or harsh, the punishments too distasteful, or the pay too low (in 1853 ordinary warders were earning 12s a week, a very low salary, while the wardresses received a third less).

THERE'S A RIOT GOING ON

On the morning of Sunday 21 December 1862 a Council officer came in through the doors of St John's Kirk during divine service and, breaking protocol, walked up the aisle and whispered into the ear of Sheriff Barclay, who was sat in his usual pew at the front. A look of concern passed across the Sheriff's face and he immediately got up and left. The minister's sermon was forgotten as the entire congregation watched the two men depart, and speculated what crisis had erupted.

Across the city the same scene was being enacted as officials, police officers and military men were pulled out of their respective churches. Soon policemen armed with rifles and pistols were commandeering cabs, and soldiers from the 25th Regiment were forming up in ranks, while the Sheriff, Magistrates, Procurator-Fiscal, and the Superintendents of the City and County police forces, were jumping into carriages. The destination for everyone was the same – the General Prison.

It had been a fraught couple of days at the Prison. The Matron had informed the Governor that illicit articles such as alcohol were being kept in the female cells. A male prisoner had been found wandering at large with a false key. Then an informer declared that a plot had been hatched for three dozen men to break out of their cells and choke the Night Watch. The aim was not to escape the prison, but to get into the female cellblock. With the majority of the prison population in their teens or twenties, sexual activity was always a concern. With tensions building to breaking point, the Governor ordered a thorough search of the female cells, and started to carry a small double-barrelled pistol as a precaution. The search turned up a number of forbidden items, plus eleven bottles of porter, a popular dark beer (how had the equivalent of a crate of beer managed to get into the cells?). With the 'booze and boys' bacchanalia frustrated, the female convicts became a seething mass of barely-suppressed violence.

Things kicked off during the morning service on Sunday, a short time after the cell search. The chaplain struggled on through a series of escalating disruptions, but then a full-scale riot erupted. The 300 women overpowered the wardresses and proceeded to smash up the chapel. The Governor entered and fired two blank rounds above the

heads of the rioters. In the pause that followed an unconscious and badly injured wardress was dragged outside by her colleagues, an action which probably saved her life. The prison staff then withdrew, barricading the rioters in the chapel. At this point the police, army and officials arrived. Presumably the initial adrenaline rush of the riot had dissipated, and at least some of the prisoners must have seen how hopeless their situation was. The tense atmosphere was defused by Sheriff Barclay, who talked the ringleaders down from further confrontation (which would probably have resulted in several deaths). Eventually all the women gave up, and were escorted back to their cells without further trouble. The prison was back to relative normality by evening, but a temporary guard of soldiers and police officers remained on duty through the night.

DEATH FROM SWALLOWING COINS

Prisoners were not allowed to possess money, but obviously a bit of cash came in handy in the internal market that was prison life, so some felons would swallow coins just prior to admission, and then keep them secret during their stay, swallowing them again just before release or moving to another prison. Obviously the coins would pass through the system quite quickly, and as there are only one or two orifices in the human body where coins could be hidden (depending on gender), I leave the icky details of the mechanism involved to the reader's imagination.

In 1870 a prisoner at Perth returned from the exercise yard to find that his cell bucket containing the overnight waste had been emptied into the common sink, as was the usual daily practice. Unfortunately for the prisoner his entire stock of coins had just passed into that vessel. Thinking the supervising warder had deliberately thrown out the money, he brutally attacked the man. The prisoner was subdued and thrown into his cell. He had been originally sentenced to eight years' penal servitude, a punishment that came in in 1853 as an alternative to transportation. It was a system divided into stages starting with extreme harshness – ten hours hard labour a day doing pointless work on the crank or treadmill, a bare plank for a bed, and no earnings, respite or privileges – and progressing through three more stages to a point where the severity of the labour was reduced, the bed always had a mattress, and the prisoner could earn money, receive visits, and have lessons, open-air exercise and library books. Normally a prisoner would be expected to progress through the stages so that his last two years in jail were relatively comfortable. The assault, however, ensured that this particular individual spent the entire eight years performing back-breaking punishments and sleeping on a board.

But there were worse fates. In the late 1880s Rebecca Bell had been sentenced in Glasgow Sheriff Court to a year's imprisonment for theft. One morning she was found dead in her cell in Perth. At the inquest it was established the cause of death was

The north wall of Perth Prison today, showing one of the main nineteenth century wings (#4 on the plan on page 36). (The Author)

"malignant disease in the abdomen." She was a known coin-swallower, having been caught in the act four years previously. This time she was not so lucky. The post-mortem conducted by Dr Macnaughton uncovered six coins in her intestines. She had died for three shillings and three pence, a day's wages for a skilled worker.

THE GREAT ESCAPES

"Some very clumsy and ludicrous attempts have been made...while others have been hatched and well-nigh carried out with consummate skill and daring."
William Sievwright, *Historical Sketch of the General Prison of Scotland*

Sievwright's book – which is a treasure trove about the first fifty years of the General Prison – described all the known escape attempts, largely drawing on the annual Prison Directors' reports. In March 1848 a man escaped, but no details were given about how he managed to do so, or whether he was recaptured (he probably wasn't). All was said was that an investigation proved that none of the prison officers were at fault. Reading between the lines, Sievwright suspected some kind of embarrassing scandal, but nothing more could be discovered. Two years later in January 1850 two youths managed to get out of the Juvenile Wing, but were immediately recaptured. This time the Governor was reprimanded while two warders were suspended for negligence (they were later reinstated).

On 30 September 1864 a dramatic tragedy marked a serious escape attempt. A party of warders and seven prisoners left Perth in the Prison Van, the supposedly secure railway carriage that was attached to normal trains when prisoners were transferred between prisons. Their destination was Portsmouth, and then Portland or Dartmoor Prisons. The van was compartmented into a series of tiny cells, each containing two chained and hobbled prisoners. The carriage walls appeared to be made of timber but were in fact wooden veneers over a solid sheet of iron. Unfortunately the designers had omitted to reinforce the roof, which was also made more vulnerable by the inclusion of ventilators. Further, the searching of prisoners had become dangerously lax. Around 1 am, just after the train passed through Crewe, two men produced a scissors blade and a piece of a knife blade, and cut through the ventilator. They climbed onto the roof of the train, which was now travelling at full speed, and jumped. Both still had iron hobbles around their ankles, which obviously reduced mobility. One man died instantly from the jump, and was found beside the track the following morning. He had been serving a sentence of fifteen years. The second man survived and went on the run. The following year he was arrested for housebreaking. When his identity was confirmed he was returned to Perth, where he found his original ten-year sentence doubled.

Also in 1864 two men in adjacent cells jimmied up a 'skeleton' key, probably from scraps of wood, leather or gas piping. The longer-armed one reached through the service opening used for food dishes, unlocked his door, then released his companion. Taking a set of improvised tools with them, they forced the padlock of a trap door leading from a sink to a furnace above, climbed up the chimney, and then broke open an ungrated skylight into the cool October night air. Several storeys up, they scooted across the roof of Wing I over to Wing II, and slid down to the ground using an iron flue. They were now in the exercise yard, with the high perimeter wall and moat between them and freedom. Ingenuity and daring athleticism had brought them this far, but now their luck deserted them, for they were too visible in the open space, and were instantly recaptured. The attempt had revealed some serious flaws in the prison security, and from then on the service hatches into the cells were always secured from the outside, while the iron flues and other chimneys were removed, along with other access routes up onto the roof or from the roof down to the ground.

Another escape attempt in January 1866 used the classic tactic of sawing through the cell window bars. The plan was cleverly executed. Each night the prisoners would carefully remove two panes of glass from the window, then patiently work away at the iron bars with a miniature saw, making sure that the iron filings were blown outside to the wind or mixed in with the cell dirt. When dawn approached they replaced the glass, securing it with putty made from their daily rations of bread or porridge. During the day the saw was handed to a prisoner who cleaned the passages in their block, and hence the tool was never found in their cell. After many nights' work the bars were

ready to snap, and makeshift ropes were hastily assembled. But then a 'stiff' (a covert written message) between two prisoners was intercepted, and at the last minute the authorities learned of the plan. The escape was thus thwarted, but how had they got hold of the saw in the first place?

Two months later in March another ingenious escape attempt took place, this one executed by a notorious English prison breaker. Whereas previous would-be escapees had largely concentrated on getting out of their cellblock, this gentleman studied the entire prison structure. He realised a successful prison break at Perth required three stages: escape from the cell; getting from the high roof of the cellblock wing down onto the exercise yard or the other open spaces surrounding the wings; then crossing this exposed area and climbing the high perimeter wall and getting down the other side. Without preparing to tackle the outer wall, just getting out of the cellblock was a fool's errand.

The first stage, escaping from the cell, involved quietly removing the mortar around the ventilator. This box-life structure was a perforated oblong piece of iron or zinc set into the brickwork of the arched cell roof. The mortar was replaced with pieces of bread and the original colour of the covering plaster replicated by a covering of flour shaken or scraped off his daily wheaten loaf. When the ventilator could be lifted out entirely, he made a pair of manilla ropes that were twisted around his hammock. When everything was ready he chose a dark night, placed a stool on his table, gently removed the ventilator and squeezed through the tiny space carrying the two ropes, some bread, and a table leg. The latter was used to prise bricks out of the ventilator shaft, which were then tied to the ropes as *de facto* grappling hooks. The table leg also helped him break through a wooden floor into an attic space. From here it was through a skylight onto the roof. The escape attempt two years previously had caused all the roof-to-ground routes to be removed, so the first rope was tied to a chimney, allowing him to descend hand over hand.

The final and most crucial stage now lay ahead. Choosing his moment when no guards were around, he flitted across the dangerously exposed exercise yard and made it successfully to the foot of the perimeter wall. The rope was whirled and thrown up, and the brick tied to the end stuck fast on the walltop. Result! The only problem was... the rope was too short. Its end dangled just out of reach, evading even his frantic jumping. A minute or two later one of prison dogs caught his scent and he was captured. It wasn't quite *Escape from Alcatraz* or the *Great Escape*, but it was a bold and daring plan, immaculately executed until the final obstacle.

CHAPTER 4

INVASION OF THE BODYSNATCHERS

"The law is an ass—an idiot," wrote Charles Dickens in *Oliver Twist*. And indeed it often was. And never was the law more idiotic than in its regulation of the supply of dead bodies for dissection.

The eighteenth century had seen great improvements in the art and science of surgery, and Scotland's medical schools in Edinburgh, Glasgow and Aberdeen were at the forefront of these developments. Scotland became *the* place for young men to take their medical education, and students flocked from England, Ireland, even North America. The Napoleonic Wars brought a massive increase in demand for surgeons who could remove a cannonball-shattered limb or extract bullets from vital organs. By the first decade of the 1800s there were over 800 students studying medicine in Scotland each year. And every one of them needed to practice their surgical skills on a cadaver.

The problem was, where were these bodies to come from? The obvious choice was from the gallows. But although there were dozens of crimes for which a felon could be hanged in Scotland, the Murder Act of 1751 specified that *only* executed murderers could be given for dissection. This was thought to be a deterrent "for better preventing the horrid crime of murder," as most people had a deep-seated fear of post-mortem mutilation, a fear that was if anything stronger than the fear of death by hanging. But even in an exceptionally violent year the number of criminals executed for murder was just a handful. Which left the Scottish medical fraternity short of around 795 corpses a year.

Thus was born the era of the bodysnatchers. Medical students, local doctors, corrupt gravediggers and common criminals laboured together in a nationwide industry of removing freshly-buried corpses from their graves, and transporting them to the anatomy classes in Edinburgh, Glasgow and Aberdeen. From the 1780s until the trade was extinguished by a change in the law in 1832, thousands of graves across Scotland were violated.

The outrages prompted various responses by parish and local authorities. Armed watchmen were employed to guard fresh graves, and watch-houses can still be seen in the graveyards of Arngask, Blackford, Caputh, Clunie, Forteviot, Kinfauns, Kinnaird, Kinross, Redgorton and Coupar Angus. The latter two sites also have morthouses, strongholds in which coffins were kept secure for up to three months, by which time their contents had putrefied and were beyond the interest of the 'resurrection men'. There are further morthouses at Collace and Luncarty. Other protection devices included mortsafes, iron cages placed around a grave. Three fine mortsafes, one of them sized for a child's coffin, can be viewed in the churchyard at Logierait. Logierait also has a pair of mortstones, large and heavy blocks that were lowered onto a fresh grave to prevent access.

BODYSNATCHING IN PERTH

As early as the 1730s Perth Council had passed a bye-law forbidding the "raising and abusing" of corpses. Later in the century Atholl House, a mansion on Watergate, was the centre of a small Perth-based cottage industry in the raising of corpses from Kinnoull graveyard for the instruction of local medical apprentices. Bodies were brought across the river at night by boat, and worked on in a secret underground anatomy room. Ironically, the site of Atholl House later became the Sheriff Court and County Buildings. By the early 1800s raids on Perthshire graveyards were intended to supply the endless market generated by the two established medical schools in the Central Belt (Aberdeen was happily supplying its cadaver needs from its own hinterland).

In 1828-9 the Edinburgh case of Burke and Hare galvanised a horrified reaction across Scotland, and many 'watching' associations were formed as a direct result (ironically Burke and Hare were not bodysnatchers but serial killers; however they fed the same need – fresh corpses for the surgeons, no questions asked). The Perth Burying Ground Protecting Association was set up in 1829, as announced in an advertisement on 11 March. "Five will Watch in Winter and Three in Summer," stated the announcement. Members paid a subscription, which ensured the remains of their own loved ones would be protected. Men of quality who did not wish to undertake the actual work of staying up through the night in a draughty watch-house and facing possible physical danger (not to mention suffering the weather and cold) could send a proxy. This could be a family member, "or one of their Shopmen, or Clerks, or Journeymen, or a Substitute belonging to the Association." Of course, someone of authority had to be in charge: "In order to insure *complete satisfaction* to the Public, it is an express Provision that not fewer than Two Principals shall be on the Watch in Winter and One in Summer".

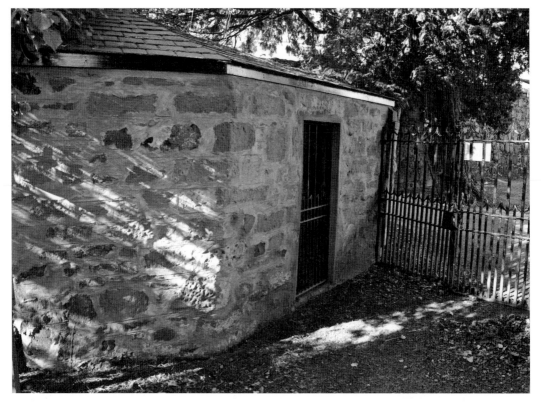

The tiny anti-bodysnatching watch-house at the gate to Kinnoull graveyard. (The Author)

By 9 April the *Perthshire Courier* gave a progress report:

"The operations of the Burying Ground Association are now going on in full activity. As many names are already enrolled as will serve a whole year, without any individual being obliged to serve twice. The nightly watch, selected by ballot, turn out regularly and readily and after a full fortnight's trial the system works exceedingly well. The public may therefore have full confidence, both in the nature of the watch and the manager by whom the proceedings are directed. The permanency of the institution must depend on the public, and a very trifling aid only is necessary. A little active countenance from the higher ranks of society would perpetuate the efficiency of this excellent Association."

The Association built a small watch-house beside the gate of the Kinnoull graveyard, the attractive site off Dundee Road on the east bank of the Tay. It is still there, but has lost its chimney and windows, and is easily missed.

THE SCOTLANDWELL SNATCH

More than eight years before the high-profile launch of the Burying Ground Protecting Association in Perth, the Kinross-shire village of Scotlandwell became the setting for a notorious case of bodysnatching. By this date several criminal bodysnatching gangs were operating out of Edinburgh, and were extending their operations further and further from the capitol. To be effective they depended on reliable informants who could tell them where and when a fresh grave was available. Some of these informants were, naturally, gravediggers. But where the request for information came from a medical professional, established community doctors often covertly assisted in the provision of local intelligence.

And so it was that at the end of February 1820 Kinross physician Dr Glass received a strange pair at the home of his brother, David Glass. On the one hand there was a man who gave his name as Mills and claimed to be a medical student at Edinburgh. But standing beside him was Daniel Butler, an ex-member of a notorious gang of London lowlifes led by career criminal Ben Crouch. Like his former boss Crouch, Butler had found London a tad too unhealthy in terms of the law, and had decamped to Scotland to give the benefit of his finely-honed bodysnatching skills to the medical gentlemen north of the border. At the time of the incident he was employed by the ultra-respectable Edinburgh surgeon Dr Lazzar. Dr Glass gave the ill-matched pair directions to Scotlandwell, complete with instructions on the location of the fresh grave. As the duo's gig trundled out of Kinross, two further men emerged from the gloom and hopped on. These were the brothers John and Andrew Herron, two of Edinburgh's most prolific bodysnatchers. The team was complete.

The following morning the inhabitants of Scotlandwell were appalled to find that the grave of weaver James Fisher at Portmoak Parish Church had been violated. Cart tracks were found leading through the frost for two miles, but they then disappeared on the road to Pettycur, the ferry port that connected the south of Fife with Edinburgh.

On 5 March Daniel Butler was back in Kinross, intending to consult with Dr Glass about a second target. But the doctor had two pieces of bad news: firstly, they had lifted the wrong corpse at Scotlandwell, having dug into the grave *next* to the one with the fresh corpse. And secondly, such a hue and cry had been raised by the incident that the police now had Butler's description. Dr Glass advised him to leave Kinross and never come back. Butler raced round to David Glass' house, where he had left two further experienced bodysnatchers, John Kerr and John Handley. And then, with perfect timing, the police arrived, delightedly proclaiming hello-hello-hello-what's-all-this-then? over the men's incriminating collection of tools – a short-handled spade and a lantern, plus ropes and sheets of coarse cloth (the latter used for holding the earth so it could be easily poured back into the grave). Butler, Kerr and Handley were arrested and taken to the lock-up at Milnathort, where they

The church at Portmoak, from where the body of James Fisher was stolen and later reinterred. (The Author)

all tried to blame each other. As the questioning proceeded they all confessed to working for Dr Lazzar.

An anonymous letter then arrived at Crown Office in Edinburgh, fingering 'Mr Mills', the supposed medical student on the Scotlandwell snatch, as a surgical demonstrator named Milne, also in the employ of Dr Lazzar. It was clearly Milne's first brush with the law, and after his arrest he confessed to the theft of James Fisher's corpse, and described how the body had been taken to Lazzar's anatomy rooms in Edinburgh's swanky Surgeon's Square.

A team of Crown officers, accompanied by James Fisher's nephews James (a weaver from Milnathort) and George (a tradesman in Edinburgh), searched Lazzar's premises. When they failed to find the body, a second anonymous tip-off alerted them to a secret underground vault hidden behind a moving fireplace. Within lay the partially-dissected corpse of James Fisher.

Meanwhile, John Herron had been arrested for a separate bodysnatching case at Abercorn, and confessed he had reluctantly been involved in the episode at Scotlandwell. He also admitted his brother Andrew had been there, which led to Andrew's arrest. Now all four of the men involved in taking James Fisher were in

custody, and three – Butler, Milne and John Herron – had confessed. It seemed that the Crown had an easy case to prove the crime of 'violation of a sepulchre'.

But Dr. Lazzar was the head surgeon of a world-leading anatomy school, one of several that made Edinburgh famous and wealthy. Any prosecution would have had to include him as a co-accused, and hence risk exposing the capitol's dirty little secret. No-one wanted to broadcast the fact that prominent surgeons routinely bought stolen corpses, no questions asked. Power, prestige and money were far more important than the theft of a poor weaver's body. Lazzar paid £15 each to James and George Fisher, which represented several months' wages for each of them. They re-interred their uncle in Scotlandwell, and the case never saw a courtroom. All members of the gang involved in both the Scotlandwell and Kinross incidents were released.

THE SCANDAL AT SCONE

The events of March and April 1820 brought a brief halt to bodysnatching outrages in Perthshire, but after six months had passed it was thought safe to try again. Near midnight on Saturday 21 October two men 'lifted' a body from the graveyard of Scone Old Parish Church on Burnside. Meanwhile at 1am another man hired a chaise at the George Inn in Perth and had the driver head out to Bridgend. Somewhere near there they met up with the first pair carrying a heavy trunk. As the three man set off, they waved goodbye to a figure standing in the shadows: this was Dr Drysdale, a Perth physician.

The trio changed carriages at Kinross and hired another chaise to take them through Fife to the ferry port at Pettycur. From there they planned to cross the Firth of Forth and deposit the corpse onto an Edinburgh surgeon's table.

At this point it all started to go wrong. The three on board the chaise were Dr James McGregor, a young Edinburgh surgeon; a man of military bearing who gave his name as Major Robertson; and professional bodysnatcher John Kerr, who had been arrested in the Kinross case and then released. The coach driver recognised Kerr, and guessed that the trunk they were all so careful of contained a dead body. He therefore gave them an ultimatum: hand over a substantial sum or be turned in to the authorities. The three called his bluff, so at Burntisland the driver made good on his threat. John Kerr managed to slip away, but the other two were stopped for questioning. As Pettycur was a customs port the customs officer for the ferry had the power to order the trunk to be opened. In contrast to the military uniforms claimed by Major Robertson, the contents were the body of eighty-year-old James Taylor of Quarry Mill. After the arrest Robertson was unmasked as a Mr. Ramage, an anatomy demonstrator at the University of Edinburgh. Both men denied any connection with the body or any associated crime.

Scone Palace, the home of the Earl of Mansfield. (Author's Collection)

The case of Dr Lazzar would have suggested that this could have been another case where the authorities looked the other way. But although James Taylor may have been a poor man, he had powerful friends. He had spent his entire life as a forester working for the Earl of Mansfield's estate around Scone Palace. His memories of the family stretched back to the 1750s, and had been regarded as a kind of living history book by his employers. The Earl took the theft of the body of his valued retainer as a personal insult to his aristocratic honour. There *would* be a trial.

Sadly even the Earl's political muscle could not bring justice for the theft of the body of the Scone octogenerian. John Kerr dropped out of sight. Ramage fled to South America. James McGregor took ship as a surgeon with the Atlantic whaling fleet. Both were outlawed. Dr Drysdale admitted acting as the lookout, but claimed he had not taken part in the violation of the grave. In the absence of the other participants, no case could be made against him and he was not charged.

James Taylor's body was re-interred at Scone on Thursday 26 October 1820. The newspaper report in which the proceedings were described also mentioned that within the past few days another body had been taken from the churchyard at Dunkeld.

CHAPTER 5

MURDER FILE №3: THE WIFE KILLERS

Most murders are committed by those close to the victim. When a married woman is found dead, the first suspect is always the husband. As these lamentable cases (and far, far too many other examples) show, such suspicions are all too often justified.

DONALD MCCRAW
MURDER OVER AN OUNCE OF TEA (1795)

Thirty-six-year-old Donald McCraw was a native of Inverness. He had pursued a living as a weaver during the great industrial expansion of Glasgow, then moved to Perth with his wife Ann Adams. By his own account he had an ungovernable temper, and over several years of marriage he beat Ann regularly. One day Ann purchased an ounce of tea on credit without telling her husband. When he was approached by the shopkeeper to settle up, he flew into a terrible rage and beat his wife to death. She was eight months pregnant. At first he fled, but after a few miles was so overcome by remorse that he gave himself up. The day before his execution he dictated a confession that included the words "I have no desire to live any longer, but wait my appointed time."

McCraw was up at the Perth Autumn Circuit on 30 September 1795. After a trial of several hours the majority verdict was Guilty. He was hanged at the eastern end of Perth's High Street on 13 November. His body was given for dissection to Alexander Munro, Professor of Anatomy at Edinburgh.

JOHN STEWART
FROM WIFE-BEATER TO WIFE-KILLER (1824)

"A man rather below the middle size, of a forbidding appearance, and seemingly of great muscular power," was how the *Caledonian Mercury* described John Stewart. He liked a drink or three. His wife, Janet Wallace, was an alcoholic. This wasn't an ideal combination, as they were in the midst of temptation and opportunity – between them they ran the Thane of Fife Inn at 28 South Street in Perth.

The servants frequently saw or heard Stewart beat his wife. The vintner would also constantly complain about Janet's drinking, and often had to lock up the pub's bottles of spirits to prevent her drinking them dry. When intoxicated she had fallen down stairs and injured herself. When she got drunk – which was often – he beat her. Sometimes he used a small stool. On 28 April 1824 Stewart launched a sustained attack that lasted fifteen minutes. The weeping woman climbed upstairs and collapsed into bed. She lost the power of speech and movement, and drifted in and out of consciousness. After three days of decline, she died, not having uttered a word since the beating.

The fact that John Stewart had caused her death was never in doubt. There were witnesses, and Janet had received medical treatment before she died – both a doctor

South Street, Perth. No. 28 is part of the high-gabled building to the left of the Salutation Hotel. (The Author)

and a nurse had seen bruises all over her body. One of the blows on the head had ruptured a blood vessel in the brain. But had the assault been a deliberate attempt to kill, or had an unlucky blow turned a violent wife-beater into an accidental wife-killer?

The jury at the trial on 17 September inclined to the latter view. After an hour's retiral they declined the charge of murder, instead finding the vintner guilty of the lesser charge of culpable homicide. John Stewart was sentenced to the highest punishment of the law, short of death. He was to be whipped through the streets of Perth and then transported for life. On 15 October the Edinburgh hangman took a whip to Stewart's back at a dozen places in Perth centre. The proceedings were watched by a large and hostile crowd, but no violence erupted, possibly because a detachment of armed soldiers was present. Two days after the public whipping – which was the last such punishment in Perth – Stewart was shipped to Dundee, and then to England prior to his voyage in chains to Australia.

JOHN CHISHOLM
ATROCITY IN SOUTH STREET (1832)

"The most abominable and revolting murder that perhaps was ever perpetrated." That was the opinion of the reporter for the *Caledonian Mercury* on the killing of seventy-six-year-old Margaret Chisholm by her husband John. So awful were the details that for six hours the proceedings at Perth Circuit Court were conducted behind closed doors, with only the court officials, jury and witnesses present. The press were only allowed back in when all the evidence had been the heard and the jury had retired. The verdict was swiftly delivered and unanimous: Guilty.

Trials behind closed doors in the nineteenth century High Court and Circuit Courts were almost always concerned with some form of sex crime – rape, incest, child sexual abuse and so on. A murder trial conducted behind closed doors was extremely unusual. We can therefore surmise that John Chisholm had not only murdered his wife, but that he had subjected her body to some kind of genital mutilation, or that other atrocities of a sexual nature had been committed. Certainly the judges (Lords Medwyn and Gillies) and other court attendees seemed utterly appalled. "Every person present," stated the *Caledonian Mercury*, "was shocked beyond expression at the horrible details and circumstances which were disclosed in the trial." A profound silence spread over the crowded courtroom as the death sentence was pronounced, a silence which gave way to disgust when the prisoner stated as he was led away, "I am innocent – I shall die innocent – and I thank God for it."

John Chisholm was a pillar of the community. His grocer's store had been a fixture on South Street for forty years. The seventy-six-year-old was a special constable and

Whereas By the Verdict of an Assize, returned this Fourth day of October One Thousand eight hundred and thirty two years, against John Chisholm, Grocer, present prisoner in the tolbooth of Perth, he was found Guilty of Murder. In respect whereof We the Lord Gillies and Lord Medwyn Two of the Lords Commissioners of Justiciary, have decerned and adjudged the said John Chisholm to be carried from the bar back to the Tolbooth of Perth therein to be detained until Wednesday the Thirty first day of October current, and upon that day to be taken furth of the said Tolbooth — to the common place of execution of the said Burgh of Perth, or to such place as the Magistrates of Perth shall appoint as a place of execution, and then and there betwixt the hours of Two and Four in the afternoon, to be hanged by the neck upon a Gibbet by the hands of the Common Executioner until he be dead, and Ordained his body thereafter to be buried within the precincts of the said Tolbooth or Prison of Perth, and that in terms of the Act passed in the second and third year of the Reign of his Majesty King William the Fourth chapter Seventy five, entituled "An act for Regulating Schools of Anatomy." We therefore hereby Ordain and Require the Magistrates of Perth and keepers of their Tolbooth to see this Sentence put in Execution as they shall be answerable as their highest peril. Given at Perth this Fourth day of October One Thousand eight hundred and thirty two ——

The Death Warrant for John Chisholm, Grocer and wife-murderer. (Perth and Kinross Council Archives)

to be hanged by the neck upon a Gibbet by the hands of the Common Executioner until he be dead, and Ordained his body thereafter to be buried within the precincts of the said Tolbooth or Prison of Perth, and that in terms of the Act passed in the second and third year of the Reign of his Majesty King William the Fourth chapter Seventy five, entituled "An act for Regulating Schools of Anatomy."

An extract of Chisholm's Death Warrant, ordering him to be buried in the prison precincts under the terms of the recently-passed "An Act for Regulating Schools of Anatomy". (Perth and Kinross Council Archives)

a devout attendee at his local church. He also had a shocking temper. His first wife had complained about his violence and warned that he "would be hanged though she would not live to see it." He had been charged early in July 1832. The trial took place on 4 October, and the execution, on the last day of the same month, attracted a large crowd, order being kept by a company of the 79th Highlanders. The scaffold was erected against the south wall of the Speygate Prison.

Chisholm's religious expression was unabated on the scaffold. He joined in loudly in the singing of a psalm, and then requested a hymn. After appealing to God as his witness that he was innocent of the crime, he stood impassive as the executioner John Murdoch adjusted the noose and the hood. Chisholm stood praying silently for a few minutes, then dropped the handkerchief that signalled to opening of the trap door.

If John Chisholm had been executed just a few months earlier, his body would have been handed over the surgeons of Edinburgh for public dissection. But in 1832 the new Anatomy Act was passed, and after this date executed murderers were simply buried, so Chisholm's body was taken into the prison precincts for interment. Unlike his wife, he was granted dignity in death.

JOHN STEWART
IN THE MOUTH OF MADNESS (1832)

Sometimes the horror and tragedy of a person's situation just leaps off the page. John Stewart was sixty-six years old, employed as a forester or woodlands manager at Cally, near Dunkeld, and had a wife he loved and eight children who were healthy and getting on in the world. He was also suffering from a serious mental illness.

Stewart had suffered from fits since a teenager. Witnesses from different periods of his life testified to his history of low moods, moroseness, irritability, altered states, paranoia and mania. One day in 1815, while employed as a gardener at Blair Atholl, he had disappeared for a day, being found in a seed shed covered with blood. It had probably been a suicide attempt. For the next month he was confined to a straitjacket and tied to his bed. Around 1825 he fled the family home in a wild state and it was only the presence of his eldest son John that prevented him taking his own life. That night the boy slept with him – Stewart told him "there was a black man standing in the room whom he wanted to be at."

When he was not ill, John Stewart functioned well. His family underwent the usual trials of relatives of the mentally troubled – embarrassment, shame, and a powerful need not to talk about their father's illness outside of the home. Sometimes when visiting Dunkeld, Stewart was teased by people calling him 'loony' and similar names, and this made him more depressed.

The view over Dunkeld and Birnam from Craig-y-Barns, the wooded hill where John Stewart was arrested. (Author's Collection)

From mid September 1832 Stewart was in decline again. He became paranoid about the woods in his charge, saying they were 'all going wrong'. He refused to go to church or perform the Sunday family routine of reading the Bible. He would stand in one spot for many minutes, fixing his eyes on the wall or a set of railings. In company he was 'absent', and responded slowly and with great agitation to conversation. He had black moods and on some days would not say a word. His wife, Christian Mackintosh, told the family she feared he would really kill himself this time. When she told him he should be happy because he was in work, had money and the children were doing well, he replied that, "He could never be happy in this world."

On the morning of Wednesday 3 October it all came to a head. After some trifling argument Stewart picked up his woodman's axe and struck Christian three great blows to the head. When his three daughters approached the house he took out a knife and tried to stab one of them. By the time the terrified girls returned with help, Stewart had fled into the woods covering the hill of Craig-y-Barns above Dunkeld. Despite the wet and stormy conditions many people assisted the police in the search. After around five hours Stewart was found about a mile from his house. He tried to reach for his clasp knife but two constables rushed him and held him down before he could harm either them or himself. On the way back he talked of putting an end to himself. He was brought to Perth on 4 October, the day John Chisholm was found guilty of killing his wife.

Like many people who are mentally ill, Stewart was not always of unsound mind. Most police, legal officials and doctors who saw him thought he was normal. Occasionally in prison he seemed to have a fit, or enter an altered state, but most of the time he was rational, if morose and irritable. His was a returning illness, but unpredictable in its duration or effects.

The trial, during the Perth Spring Circuit on 18 April 1833, was deeply emotional for his children, four of whom gave testimony about the murder of their mother and their father's mental decline. Most of the 12-hour-long trial was taken up with declarations about Stewart's mental state, as his counsel had lodged a special defence of temporary insanity. Few of the experts could agree, and one doctor changed his mind, and gave his opinion that whereas he had previously thought Stewart wholly sane, now he considered him to have been suffering from a state of 'melancholy fury' at the time of the murder.

Perhaps not surprisingly the jury were unconvinced by the nuances of the medical experts' diagnoses and jousting opinions, and after retiring at 10.45pm returned within a few minutes with a majority verdict of Guilty of murder. John Stewart was sentenced to be hanged on 14 May 1833. This sentence was quickly reduced, with his punishment commuted to transportation for life.

JOHN YOUNG
DEAD DRUNK (1885)

On 8 October 1885 John Young found his wife in a drinking den run by Jane Angus in Leslie Street, Blairgowrie. He launched a furious attack of punches, slaps and kicks at her, and she later died of her injuries. Young pleaded guilty to culpable homicide at the Circuit Court of Justiciary in Perth on 19 January 1886. Extensive evidence was given showing that Mrs. Young was a notorious drunk, while the forty-eight-year-old coal agent was provided with many certificates of good character from the great and good of Blairgowrie. Lord Young stated that the circumstances were wholly exceptional and passed a very lenient sentence of six months. In the next case, the same amount of jail time was awarded to William Dick of Blairgowrie for stealing six ewes and five lambs.

CHAPTER 6

"TO BE HANGED BY THE NECK UNTIL HE BE DEAD..."

Executions for theft and other lesser crimes

This chapter deals with cases where convicted felons were sentenced to death for crimes such as theft, housebreaking and sheep-stealing.

JOHN LARG, JAMES MITCHELL AND ALEXANDER STEEL
STOUTHRIEF AND ROBBERY (1816-7)

These three unlovely gentleman attacked the tollhouse at Friarton on the night of 12 November 1816. A tollhouse was the home of the tollkeeper, who was in charge of the tollbar that blocked a turnpike road, and took the tolls or fees from travellers. Because tollhouses obviously had money on the premises, and were often in isolated spots, they were frequent targets for criminals. The Friarton building still stands on the southern edge of Perth, on the road to Bridge of Earn.

The trio arrived just after midnight and banged on the door demanding first small beer, then water, and then whisky. The tollkeeper William McRitchie refused to open up, and the three became angry, particularly when McRitchie rebuffed their offer of a shilling for the whisky. They threatened to set the cottage on fire, pull down the walls and kill all within. One of the men then smashed a window and pointed a pistol inside, saying he would blow the tollkeeper's brains out. In fear of their lives, McRitchie and his wife Emilia Craigie unlocked the door, whereupon Mitchell pressed the pistol against the tollkeeper's chest and Larg threatened to kill Emilia. Verbal threats were also made against the couple's children, who were in the back room. The terrified woman handed over 8s 6d of their personal money, but her husband cannily foiled the robbers. He took two pocket books from a drawer, using the poor candlelight to avoid being seen as he hid the one with the day's takings. The other contained two guinea notes which he knew to be worthless forgeries; but these he handed over to the thieves. In theory the trio had scooped £2 10s 8d, but

Perth from the Edinburgh Road. In the distance can be seen the General Prison. The Friarton tollhouse is in the foreground. (Author's Collection)

because of the forgeries the actual usable value of their haul was just eight shillings and sixpence.

Meanwhile, the McRitchies' servant, Charlotte Taylor, had jumped out of the rear window and ran off, being pursued for a short time by one of the robbers. When she returned with assistance all the men were gone, leaving behind three witnesses who could identify their assailants and their clothing. A hue and cry soon turned up the culprits. On the day after the raid, Mitchell's wife Lydia Barber had tried to pay for goods at David Christie's shop with one of the guinea notes; Christie had recognised it as a forgery and refused to accept it. Soon after the authorities visited Mitchell's house; Lydia Barber said she had burned the note, but it was found in a cupboard – marked as issued by the Perth Banking Company, it was an exact match to one of the bad notes handed over at gunpoint by William McRitchie. A search of the premises also turned up the loaded pistol hidden in the internal coal-hole; the distinctive coats and bonnets worn by the men during the attack; and, skulking in a coal cellar, a certain John Larg.

James Mitchell himself obviously knew that the gig was up, for he went on the run. After a few days he was apprehended at Torryburn and taken into custody on 23 November. Knowing he was to be confronted by the pair he had robbed, he shaved off his whiskers, thus hoping to avoid identification. It didn't work.

The former Friarton Tollhouse on Perth's busy Edinburgh Road, in 2010. (The Author)

Mitchell and Larg were indicted at the High Court in Edinburgh on 8 January 1817, the main trial taking place on 20 January. Alexander Steel was also accused, but was outlawed for not appearing in court. The charge was robbery and stouthrief, the latter an offence unique to the Scottish legal system meaning theft with violence. It was typically used for the violent entry or robbery of a dwelling-house. Mitchell was thirty-six years old and Larg about twenty-one. Both worked in the same weaving shop, while Mitchell was a former naval seaman and Larg a member of the part-time Perth volunteer militia. Rather stupidly, on the night of the crime he had been wearing his distinctive military cap, embroidered RPM for Royal Perth Militia. Both men pleaded Not Guilty but their case was a forlorn one. They attempted to do the usual thing, blaming the crime on each other. Larg said Mitchell and Steel had gotten him drunk and seduced him into doing the crime against his will. Mitchell claimed he was home in bed at the time of the robbery, and that the guinea note found in his house had been given to him by Larg. Their excuses were so obviously transparent that the jury took less than five minutes to find them both Guilty. The sentence was death.

The two men were taken under guard from Edinburgh to the border with Linlithgowshire, where the county Sheriff took charge of them. Similar transactions took place at the county boundaries of Stirlingshire and Perthshire, until the two miscreants were incarcerated in the old Tolbooth in Perth.

Curia Itineris Justiciarii S. D. N. Regis, Tenta in Prætorio
Burgi de *Perth, decimo Sexto*
die mensis *Aprilis* — Anno Domini Millesimo
octingentesimo et decimo *Octavo* per
Honorabiles *viros Georgium Fergusson
de Hermand et Adamum Gillies
armigerum*
duos ex Commissionariis Justiciariæ dict. S. D. N.
Regis.

CURIA LEGITIME AFFIRMATA.

Intran. *Alexander Steel present prisoner
in the Tolbooth of Perth*
Pannel.

INDICTED and ACCUSED, at the instance of His Majesty's Advo-
cate, for His Majesty's interest, of the crimes of *Strouthrief
& Robbery* as particularly mentioned in the Indictment
raised and pursued against *him* thereanent. IN RESPECT of
the verdict of Assize dated and returned *this day*,
whereby *he is found Guilty on confession*
The Lords *Hermand & Gillies* DECERNED and
ADJUDGED, and hereby DECERN and ADJUDGE the said
Alexander Steel Pannel to be transport-
ed beyond Seas, to such place as His Majesty, by and with the ad-
vice of His Privy Council, shall declare and appoint, and that for
and during all the days of *his life* from and after the
date of this Sentence; WITH CERTIFICATION to *him*
that if, after being so transported, *he* shall, all the days of
his life return to, or be found at large within any
part of Great Britain or Ireland, without some lawful cause, and
shall be thereof lawfully convicted, *he* shall suffer Death,
in terms of the Statute passed in the Twenty-fifth year of the Reign
of His present Majesty, entitled, ' An Act for the more effectual
' Transportation of Felons and other offenders in that part of
' Great Britain called Scotland.' And grant warrant to the Ma-
gistrates of *Perth* and Keepers of their Tolbooths,
to detain the said *Alexander Steel* until
delivered over for Transportation, in terms of this Sentence.—Ex-
tracted, from the Circuit Court Books, by

Jo. Anderson
Circuit Clerk

The Warrant sentencing Alexander Steel to transportation for life for strouthrief
and robbery, under the terms of "An Act for the more effectual Transportation of
Felons and other offenders in that part of Great Britain called Scotland." (Perth
and Kinross Council Archives)

The jury, reluctant to enforce a capital sentence on a crime where no murder had been committed, had recommended mercy; no mercy was forthcoming. On 28 February 1817 John Larg and James Mitchell were brought out to the gallows at the eastern end of the High Street. "They both behaved with becoming penitence and resignation," noted an approving press report of the time. Georgian commentators loved repenting criminals and pious addresses from the scaffold, and John Larg did not disappoint them. He warned the assembled multitude to let his dreadful fate be a warning against sin, and advised all and sundry to avoid the behaviour that had brought him to this terrible end, *viz* drinking, gambling and 'night rioting'. The two men were hanged simultaneously, each holding the other's hand. The executioner's name was not recorded.

But what of their accomplice, Alexander Steel, outlawed for non-appearance? He had less than a year's grace. By 2 February 1818 he was imprisoned in Perth, and was soon charged with the attack on the tollhouse. Sensibly, he confessed, and avoided the death penalty, getting transportation for life. It was made clear to him what the sentence actually meant: that if he ever returned to Britain his life would be forfeit.

MALCOLM CLARK
STOUTHRIEF AND ROBBERY (1817)

This good-looking young man had not yet reached his twentieth year when he was involved in a nasty case of home invasion. At three in the morning on 9 April he and George McMillan knocked on the door of William Rattray, a shoemaker in West Toft, near Kinclaven, several miles north of Perth. Their flimsy excuse was that they were after a light for their pipe. Rattray said he had no light, and went back to bed. The two men could be heard patrolling and muttering about outside, and then within half an hour of the first visit, the front door burst open. Helen McGrigor, Rattray's wife, cried out "Load the gun!" in an effort to frighten the men off, but it was a bluff, as there was no weapon in the house. Clark and Macmillan were armed with large sticks, and rushed about shouting "Where is the man with the gun?" and demanding money. For the next two hours the husband, wife and their daughter were terrorised in their own home, as Clark roughly ransacked all the drawers and furniture, and his companion kept a watch on the householders. At one point Helen and the girl attempted to get out of bed, and Macmillan swung his big stick menacingly at them. Fortunately no one was actually hurt, and the duo left with Rattray's pocket book containing some cash.

Stanley residents Clark and Macmillan were presumably not the brightest bulbs in the bulb-box, because they had targeted a relatively near neighbour who knew what Clark looked like. Plus, they didn't exactly lie low. Shortly after the outrage at West

Toft, they broke into four different houses in the Stanley area, and then smashed up machinery in the Stanley cotton mill. "So great was the alarm excited by these men," reported the *Caledonian Mercury*, "that the country people rose in a body and pursued them across the Tay, at the boat of Kinclaven, where they were taken and secured." On Friday 18 April the two men were committed to the Tolbooth, before being moved to the new Speygate prison later in the year.

On 18 September Clark was charged with stouthrief at the Autumn Circuit; George McMillan, however, had escaped from the state-of-the-art prison, thus adding 'Embarrassing Perth Council' to his rap sheet. McMillan was outlawed. Clark confessed to the West Toft attack and pleaded Guilty, which usually would have meant no trial, but for some reason the Crown wanted to have justice seen to be done, and so proceeded to swear in a jury and went through a trial. Inevitably, the verdict was Guilty. By a majority, the jury recommended him to mercy on the grounds that he had candidly confessed, that he was a young man, and that no one had been injured during the crime. The judges, however, disagreed, comparing the case to John Larg and James Mitchell, who had been executed for stouthrief at the Friarton tollhouse earlier that year.

The Lord Justice Clerk then adopted the tone and form of words so familiar from similar cases: "Malcolm Clark, it is now my painful duty to announce to you the dreadful sentence which the law has annexed to the commission of such crimes as those of which you have now been convicted…that dreadful sentence of the law is that you shall suffer the last punishment on the 31st of October next, at the common place of execution in this city."

His Lordship continued with the moral tone that was imperative for judges of the day: "It is indispensably necessary that offences of this description should be visited with the most exemplary punishment, uniting as they do, the crimes of house breaking, with the application of that force and violence which constitutes robbery.…It well becomes you, therefore, to prepare with seriousness for the awful occasion which is to make you a public spectacle, to deter others from following the same course. I implore you to apply with fortitude and resignation to that thorough repentance, which alone can appease the wrath of the Almighty, for, by your own confession, you have been guilty of six separate and grievous offences, in violation of his commandments. Pray that through the merits of our Saviour he may forgive you this and every other offence…recollect that your days are few and numbered, and that ere long you must appear at the Judgement Seat of God to give an account of your actions. I once more entreat you not to lean on that recommendation of mercy which has proceeded merely from a majority of the jury, but to prepare yourself for the punishment which I am afraid awaits you. I have only to express my hope that the example of a young man thus untimely cut off will have its proper effect."

Malcolm Clark did indeed spend his final days in religious enthusiasm and praying for forgiveness. An appeal was lodged, but four days before his scheduled date with

destiny, he learned the petition had been denied. On 31 October he travelled the few hundred yards from Speygate Prison to the execution site at the end of High Street, where John Larg and James Mitchell had been hanged seven months previously. With him on the scaffold was George Wyllie, who had been convicted of housebreaking and theft in Kincardine at the same sitting of the Circuit Court. Each addressed a prayer to Almighty God, shook hands with each other, and calmly submitted to receiving the hood and noose. Malcolm Clark's final words were "Lord, be merciful to us, poor sinners! Lord Jesus receive our spirits." He then dropped the napkin that signalled readiness, and the two men breathed their last.

ALEXANDER REID
SHEEP-STEALING (1820)

'Might as well be hung for a sheep as for a lamb.' One of the half-jokes commonly made about nineteenth-century justice was that a man could be hanged for simply stealing a sheep. In Alexander Reid's case, he compounded this by stealing a whole flock.

Pitlochry in the nineteenth century. (Author's Collection)

Whereas by the Verdict of an assize Alexander Reid present prisoner in the tolbooth of Perth, has been found Guilty of the Crime of Sheepstealing Therefore he is by me the Lord Justice Clerk. and Lord Pitmilly one of the Lords Commissioners of Justiciary. Decerned and adjudged to be carried from the Bar back to the tolbooth of Perth, therein to be detained until Friday the twenty third day of June next to come. and upon that Day. betwixt the Hours of Two & Four in the afternoon. to be taken from the said tolbooth to the Common place of execution of the said Burgh. and there. by the Hands of the Common executioner to be Hanged by the Neck upon a Gibbet untill he be Dead. which is pronounced for Doom: Requiring hereby the Magistrates of Perth. and Keepers of their tolbooth, to see this Sentence put in execution as they shall be answerable at their highest peril. Given within the Criminal Court House of Perth this eighth day of May eighteen Hundred & twenty years.

D Boyle

A Monypenny

The Death Warrant for Alexander Reid. (Perth and Kinross Council Archives)

Extract from Reid's Death Warrant. "Guilty of the crime of sheepstealing." The death sentence was later commuted to transportation for life. (Perth and Kinross Council Archives)

Reid's father had been the previous tenant of the sheep farm at Old Faskally, in Highland Perthshire near Pitlochry. In 1820 the present tenant, John Menzies, performed his bi-annual count on his stock of 1200 animals, and found he was missing over 50 ewes and wethers (wethers are castrated male sheep, the name distinguishing them from rams). His shepherds made enquiries at the livestock markets in Perth, and followed a trail to several farms in Fife. In each case his animals could be clearly identified by an iron burn mark on the horn and an 'S' painted on one side with tar. The farmers had all bought the stock in good faith from Robert Russel, a tenant farmer and sheep dealer. Russel in turn had bought a total of ninety-six sheep off Alexander Reid at markets in Perth and Cupar, purchasing them for an average of 15s 6d each and selling them on at a profit of 4s 6d per animal. The deals would have netted Reid around £75. Some of the additional animals had been taken from John Menzies' neighbour, Mr. Campbell of Corrieglass farm. Reid had told Russel he bought them off a Highland farm. All the stolen animals were recovered and returned to their owners, leaving the Fife farmers severely out of pocket.

There was never any doubt about Reid's guilt. Several witnesses had seen him droving the flock between Pitlochry and Perth, and others noted how he went from being penniless to having enough cash to own a horse and start buying other flocks. Reid made up various stories about his new fortune, but they were transparent lies. The jury took just a few minutes to find him guilty, and recommended him to mercy on account of his previous good character. The judge had different ideas, however, and Reid was sentenced to be hanged in Perth on 23 June 1820.

Remarkably, however, a petition to commute his sentence was actually approved. A few days before his due date of execution, Alexander Reid was offered an alternative sentence of transportation for life to the penal colony in Australia. He took it.

One of the factors that became more evident as the nineteenth century progressed was that Scottish juries became more reluctant to reach a Guilty verdict in respect of many crimes for which the death penalty was an option. Clearly jurors were unhappy about condemning someone to death for theft, housebreaking and other

crimes of property. Although this deeply enraged some of the 'hanging judges', some adjustments had to be made, albeit slowly. Transportation became more and more used as a punishment and – murders and other truly serious crimes aside – execution started to move from being the only choice, to being the option of last resort.

CHAPTER 7

MURDER FILE №4:
DEATHS IN THE FAMILY

It is an unpalatable fact, but when it comes to violent death we are more at risk from our nearest and dearest than from any stranger or calculating criminal. As these tales show.

JAMES GOW
THE SWEETHEART MURDER (1799)

Janet Brown was a farmer's daughter from Ballinlick, west of Dunkeld and north of Trochry and the River Braan. For some time she had been courting James Gow, a weaver at Newtown of Ballinloan just up the road. On 7 October 1799 she and James engaged in a typical teenage ruse to meet up. He waited outside the farmhouse late at night, and when the dog started barking Janet went outside 'just to check what the noise was'. She did not return so her parents assumed she had gone over to her brother's house close by.

The next morning the young girl's body was found in the well next to the farmhouse. Her neck and abdomen bore marks of violence, with the bizarre addition of a clear bitemark on the right arm. Her boyfriend was instantly apprehended. It was surmised Gow had wanted sex; when Janet refused, he assaulted and then murdered her, his passions so inflamed that he bit into her arm. But the Crown had difficulty making a case. There were of course no witnesses, and forensic science was in its infancy. Gow could not be placed with certainty at the scene of the crime, and the possibility loomed that another, unknown man had taken Janet Brown's life.

The case was first brought to the Perth Spring Circuit Court on 10 May 1800, but the case was deserted *pro loco et tempore* ('without place and time') and Gow was *assoilzied simpliciter* (acquitted) and dismissed. What all this legalese meant was that the prosecution needed more time to make its case and that all proceedings were

suspended temporarily; Gow had to turn up when the trial was next called. In the meantime he continued to be detained in the Tolbooth.

Gow finally had his day in court during the Autumn Circuit on 26 September 1800, more than eleven months after his arrest. But even with the extra time, the prosecution case was weak. After a full day's proceedings the jury retired at 9pm. They were back at 9am the following day. The majority verdict, with one dissenting voice, was Not Proven.

No other prosecution was brought for the murder of Janet Brown. The teenage girl was forever to be denied justice. The case maybe the oldest unsolved murder in Scotland.

PIERCE HOSKINS
MURDER OF HIS OWN SON (1812)

On 23 April 1812 the Spring Circuit Court in Perth dealt with two cases of theft, then outlawed a dissenting clergyman for celebrating clandestine marriages. The minor business dealt with, the court moved on to consider the case of Perth shoemaker Pierce Hoskins. Hoskins had been a soldier, serving in America and the East Indies. For some years he had been subject to fits of delirium, exacerbated by drink. On 17 Sept 1811 several witnesses had seen him in repeatedly stab his four-year-old son when in such a state. The case was straightforward, and the jury delivered a unanimous verdict of Guilty, but considered that the crime was committed in a temporary fit of insanity. The Court ordered Hoskins to be detained in prison for life on account of his insanity; he could only be released if some other safe custody was found.

The only place where the mentally ill could be incarcerated in Perth at the time was the Tolbooth. In 1805, for example, Grissel Kelly – "much deranged in her mind and so unmanageable that no private person will take charge of her" – was kept there in detention "till she become more calm". Unfortunately it was the worst place imaginable for such people. In 1818 two "lunatics" were kept in solitary confinement here, their appalling conditions described by prison reformist J. J. Gurney in his book *Notes on a visit made to some of the Prisons in Scotland and Northern England.* "In these closets, which are far more like the dens of wild animals than the habitations of mankind, the poor men…were in fact treated exactly as if they had been beasts." No-one looked after the pair apart from a Perth man who was paid to come into the Tolbooth and feed them twice a day. A few days after Gurney's visit one of the lunatics was found dead in his bed. It is possible that Pierce Hoskins was one of these two men.

JANET STEWART
THE BIRNAM BROTHER-IN-LAW MURDER (1832)

Family quarrels and alcohol probably lead to more tragedies than any other factor. This was certainly the case on 17 May 1832 when two tinker couples got into a drink-fuelled fight at Birnam. Janet Stewart and her husband Duncan Stewart had set up a temporary camp with Duncan's brother David Stewart and his wife Mary McPhee, just east of the Birnam Inn, between the Perth-Dunkeld turnpike and the River Tay. With them were Janet's four young children and Mary's single child. The group usually travelled together as they tramped the roads looking for temporary labour and making cutlery and repairing pots and pans. Itinerant tinkers, sometimes called gypsies and more recently travelling folk, had been part of Scottish rural life for as long as anyone could remember, and Perthshire had a sizeable population. They had a reputation for being 'rough'.

That night something was uglier than usual. The group had set up camp around 4pm and had exchanged some spoons for whisky at the Inn. They later sold some items and so had enough money to buy another flagon of whisky. By around 11pm there was some kind of drink-fuelled argument going on. David Stewart in particular was acting very aggressively, wielding a stick and offering to fight William McIntosh, James Robertson and James Christie, two local men and a youth who happened to be passing. McIntosh, a malster at Birnam Distillery, had given a halfpenny to Janet's oldest child and advised her to stop the quarrelling and take the children to a warmer

Birnam in the nineteenth century. (Author's Collection)

and more comfortable spot. (Much of the conversation that night had taken place in Gaelic, which seems to have been the first language of the tinkers. McIntosh, Robertson and Christie also knew Gaelic. As far as can be made out, they all gave evidence in English.) The men retreated a bit from David Stewart's threatened violence, but continued to watch the group shouting and swearing at each other: an encampment of tinkers in full drunken incandescence was clearly a spectacle worth seeing.

As with most such arguments, no one could really remember what had made the situation move from verbal into physical violence, but at some point Duncan and Janet left the fireside and David called a final parting insult and offered to fight Duncan. His brother threw off his coat and accepted the challenge. David said "by his soul he would do him with the stick" and one of the children cried, "Oh, he'll kill ye, father". The two men set at each other with sticks and fists. Duncan's dog also attacked David, holding him by the shoulder. David was getting the better of the vicious encounter when Janet joined the fight on her husband's side. She struck her brother-in-law several times.

As the local witnesses looked on in horror, David staggered back saying "she has a knife." He fell down, and quickly breathed his last. Janet was now lying on the road crying.

McIntosh, Robertson and Christie went to fetch the authorities. Later that night Duncan and Janet were arrested while sleeping in a shed. Janet asked leave to go outside and relieve herself. While she was doing so fifteen-year-old James Christie saw her throw something into the hedge, and heard a clink. Back in the shed Janet asked one of the men present, Thomas Connacher, the servant to Mr Dewar of Birnam Inn, to search her, confidently asserting he would be certain to find no weapon in her pockets. Christie told the others what he had seen, and a search soon found the knife in the hedge.

Both Duncan and Janet were accused of the murder. At the trial, which took place at the Autumn Circuit Court in Perth on 5 October 1832, Dr Malcolm's post-mortem report described five stab wounds, including one in the middle of the sternum, and three on the upper back and neck. The fatal wound had entered between the third and fourth ribs, and had penetrated the lung. There was very little blood on the outside of the chest, but inside the entire thorax was swimming in blood. Death had been almost instantaneous. Janet denied being close to the fight, saying she had been on the ground at the time, and claimed to not even know that David had been stabbed and killed until she was arrested. As a further ploy, she suggested the death blow had been struck by Mary McPhee, or by Duncan. She said her husband had told her after the fight, "I have stuck my brother very sore," to which she responded, "Duncan, Duncan, will you not run, for you will be catched and carried to Perth?" But he said he would not run.

Janet's protestations of innocence and attempt to foist the blame onto her husband cut no ice with the jury, who had been impressed by the testimony from McIntosh,

Robertson, Christie and other witnesses. By unanimous votes during a fifteen minute retiral they found Duncan Stewart Not Guilty, but Janet Stewart Guilty, with a recommendation of mercy. She was sentenced to be hanged and buried in the precincts of Perth jail on 31 October. When the sentence was pronounced Janet became deeply emotional, and pleaded for mercy for the sake of her infant children and aged mother.

On 27 October the scheduled execution was postponed for three weeks to allow further enquiries to be made. In November Janet was offered a commutation of the death sentence on condition she agreed to be transported to New South Wales or Van Diemen's Land, "for the term of her natural life".

Within the archives at the A. K. Bell Library in Perth is a document dated 1832 and entitled 'List of female convicts under sentence of transportation in the Gaol at Perth'. Among the thirteen names is Janet Stewart, described as twenty-eight years old, in good health, with a good conduct record in prison and no previous convictions. She had four children aged two, four, seven and eleven years old respectively. A handwritten note on the list reads: "Wished her three youngest to come with her else she will not survive."

JAMES MCCABE AND THOMAS RYDER
THE DEATH OF ANN MCCABE (1886)

"Come up, Mrs. Kean, my mother's dead." These were the words of fifteen-year-old Thomas McCabe in the early hours of 17 March 1886. The neighbour mounted the stairs and found Ann McCabe lying motionless and naked in the bed, her soaking wet garments on the floor, her skin cold and her face and head bloodied. Ann's husband James was warming a piece of flannel to apply to her chest, but it was soon discovered that the forty-something woman was beyond help.

Ann, James and Ann's nephew Thomas Ryder had spent the evening drinking heavily in the Crown Inn, on Crieff's East High Street. It was a bitterly cold night, with snow on the ground. Around three in the morning the McCabes' downstairs neighbour Peter McGlashan heard a sound as of a body being dragged up the stairs. A short time later Mary Kean was banging on his door, shouting "Get up, for God's sake; Mrs. McCabe's poisoned."

The case was heard at the Spring Circuit in Perth on 22 April 1886. Thomas Ryder was a thirty-two-year-old discharged soldier now earning a living as a shoemaker, while James McCabe was forty years old and a contractor. The two Irishmen were charged with culpable homicide. Ryder and the McCabe family lived opposite each other at North Bridgend in Crieff. James and Ann, who sometimes used her maiden name Mulerone, had half-a-dozen children, ranging in age from six to twenty. The

eldest was due to graduate as a priest from a Catholic college in Spain, and for this reason James had been keen to keep the lid on the fact that his wife was an alcoholic. Many witnesses testified that he had always been on good terms with Ann.

The witness testimony made it plain Ann McCabe was alive at 10pm and dead by 3.30am, but the time of death remained elusive. Dr Stirling of Perth and Dr Thom of Crieff gave the opinion that the injuries to the head had not been fatal, but the shock, combined with her alcohol intake, had made the woman vulnerable to the cold; the exact cause of death was exposure. The question was, had James and Thomas, by neglecting to care for her in the wintry conditions, been culpable for her death? Even more sinisterly, had they – or someone else – actually struck the blow that eventually brought about the woman's demise?

Several witnesses had seen Ann lying helpless in the snow, then being carried by the two men, and finally being dragged by the arms along Duchlage Road. All were in agreement that the trio were heavily intoxicated. But what exactly happened was obscured by a mess of contradictions. One said he had seen Ann fall three times, hitting her head on a kerbstone. Another testified that one of the men had angrily said to the woman, "If you don't get up I will knock your brains out," and that James then hit the woman hard with an umbrella. Yet another said Thomas had punched her to the ground, while a fourth heard him say to the prone woman, "It was all for your own good." Further witnesses thought the drunken men were very concerned for the woman, while the night watchman at the railway station said he would loan them a barrow to get her home, but got no answer. Befuddled by alcohol and dragging an unconscious woman through the snow, James and Thomas took several hours to travel from the Crown Inn to North Bridgend, a distance of some two-thirds of a mile.

James McCabe's testimony was similar, but at the same time very different. He insisted Ann had not been drinking, and that she left the pub before him. When he found her an hour later in Duchlage Road she was on her back and gave the appearance of having been attacked and robbed. Perhaps two pounds was missing from her purse, her shawl was off, and her upper garments opened. He and Thomas – who were definitely not drunk – then struggled to take Ann home, alternately lifting and dragging her for a trip lasting about an hour. He denied striking her. Both men got the impression she was drunk, and became annoyed at her, with James angrily leaving for a spell to get a whisky in the Commercial Inn on Commissioner Street. All this time Ann was mostly insensible, or barely conscious.

By the time they got home both men were convinced Ann had been given poisoned or drugged whisky, as that was the only explanation for her advanced intoxication. James told his son Thomas to get Dr Gardiner to bring a stomach pump, but the doctor would not come. When James was arrested, he was still maintaining his wife had been attacked and/or poisoned.

A view of Crieff around the end of the nineteenth century. (Author's Collection)

The jury's verdict was delivered on the second day of the trial, after a retiral of 35 minutes. They had clearly concluded that Ann McCabe had fallen and hit her head, and that, through a combination of their own drunkenness and an annoyance with another apparent display of Ann's shameful alcoholism, James and Thomas had kept her in the cold for so long that she had died of exposure. The rough treatment, such as the dragging through the snow, may have accidentally contributed to the cause of death. By a majority the jury found both men Guilty of culpable homicide by negligence only, with a recommendation for leniency. Lord Mure commented that he was "always ready on every occasion to give effect to such a recommendation" and passed down a short sentence of nine months each. With their parents not available to care for them, the five McCabe children were being looked after by the Crieff Parochial Board, one of a system of institutions set up in 1845 to provide minimal support for the poor in rural districts.

CHAPTER 8

MURDER FILE №5: JOHN KELLOCHER

The Murder of Janet Anderson (1848)

John Kellocher, also known as Kelcher or Hickie, was a strongly-built twenty-seven-year-old who had formerly worked as a fisherman and a labouring navvy. Janet Anderson was a frail elderly woman who ran a refreshment shop at Blackford, and had been Kellocher's landlady when he lodged with her during the construction of the Central Scotland Railway. Four years after the railway job had finished, the destitute Kellocher had called on Old Jenny. She was pleased to see him again and invited him inside.

He repaid her hospitality by taking the household axe from beside the door and striking her twice on the head, fracturing the skull. She remained alive, but unconscious, for several more hours. Meanwhile, Kellocher ransacked the house, stealing £3 of Janet's money and £9 15s belonging to her lodger James Morrison. He had plenty of time, because everyone else in the household, including the lodger and Janet's son the village blacksmith, was away at church, it being Communion Sabbath day. The tiny hamlet of Buttergask, two miles west of Blackford, was empty that Sunday morning as John Kellocher, murderer and thief, quietly slipped away.

The crime took place on 19 November 1848. On 2 May 1849 he called out "Not Guilty" in a confident voice when asked how he pled at the Perth Spring Circuit Court. A few hours later the jury, after a retiral of less than fifteen minutes, declared "We find the panel guilty as libelled." At the verdict Kellocher's cool demeanour, maintained throughout the trial, dissolved in a flood of tears. The court waited in silence for him to compose himself, and then Lord Medwyn placed the black cap over his wig, meditated on the atrocity of a strong man who would kill and rob an old woman who had shown him nothing but kindness and hospitality, and then solemnly pronounced the sentence of death.

Kellocher listened to the sentence standing erect and defiant, then launched into an explosion of abuse, cursing the court, the jury and the judges, and insisting he had not received justice. His ire towards those who had condemned him continued during

his first weeks in prison, and his visitors got used to him exploding in fits of temper. But as time went on he seemed to come to terms with his situation. He controlled his passions, his air of bravado lessened, and he seemed to slip into a kind of cool resignation. For the first time since his childhood in the village of Milton Malbay in Ireland's County Clare he developed a devout religious interest, largely prompted by the continual attentions of three Catholic gentlemen, the Revd J. S. McCorry, the Revd McKay of Murthly, and a civil engineer named William Milner. In their absence he counted his rosary beads continually.

On 28 May, the day before his execution, a contrite and subdued Kellocher stood before McKay and Milner and made a full confession of his crime. He acknowledged the justice of his sentence, apologised for his outbursts against the judge and jury, and expressed his sorrow for the murder. His companions were duly impressed by his sincerity.

Throughout his confinement Kellocher had slept and ate well, but on the evening following his confession he was denied sleep. At 2am he requested an audience with William Milner, who prayed and talked with him for four hours. At 6am the two priests arrived, and undertook a formal religious service. Outside the Speygate Prison, the soldiers at the 93rd Regiment, stationed at the Perth Barracks, took up positions within a semi-circular line of palisades stretched around the scaffold, supplemented by police officers from the city and county constabularies, and the High Constables of the city. The construction of the device against the outer south wall of the prison

The car park behind the Sheriff Court, from Canal Street. Speygate is on the left. In 1849 this position would have given a front-row view of the hanging of John Kellocher. (The Author)

Whereas By the Verdict of an assize returned on the second day of May One thousand eight hundred and forty nine against John Kellocher or Kelcher, present Prisoner in the Prison of Perth, he was found guilty of Murder. In respect whereof We the Lord Mackenzie and Lord Medwyn Two of the Lords Commissioners of Justiciary have Decerned and Adjudged the said John Kellocher or Kelcher to be carried from the Bar to the Prison of Perth, therein to be detained until Tuesday the Twenty ninth day of May current and upon that day, betwixt the hours of Eight and Ten of the forenoon, ordained him to be taken forth of the said Prison to the common place of Execution of the Burgh of Perth, or to such place as the magistrates of Perth shall appoint as a place of Execution, and then, and there, by the hands of the common Executioner, to be hanged by the neck, upon a Gibbet, until he be dead; and ordained his body, thereafter to be buried within the precincts of the said Prison of Perth; We therefore hereby Ordain and Require the Magistrates of Perth, and Governor or Keepers of the Prison of Perth, to see the said Sentence put in Execution as they severally shall be answerable at their highest peril; Given at Perth this Third day of May One thousand eight hundred and forty nine Years.

(Signed) I. H. Mackenzie
I. H. Forbes

John Kellocher's Death Warrant. (Perth and Kinross Council Archives)

John Kellocher or Kelcher to be carried from the Bar to the Prison of Perth, therein to be detained until Tuesday the Twenty ninth day of May current and upon that day, betwixt the hours of Eight and Ten of the forenoon, ordained him to be taken forth of the said Prison to the common place of Execution of the Burgh of Perth, or to such place as the magistrates of Perth shall appoint as a place of Execution, and then, and there, by the hands of the common Executioner, to be hanged by the neck, upon a Gibbet, until he be dead.

Extract from Kellocher's Death Warrant. "By the hands of the common Executioner, to be hanged by the neck, upon a Gibbet, until he be dead." (Perth and Kinross Council Archives)

had attracted large numbers during the previous day. By 8am a crowd of 5000 had gathered.

At five minutes past the hour Kellocher walked out, accompanied by the two priests reading from the Catholic ritual, with Mr. Milner bringing up the rear and repeating the appropriate responses. The Magistrates, Dean of Guild and the prison chaplain followed behind. Kellocher seemed oblivious to anything except his religious devotions. He walked onto the platform with a firm step, then he and the two priests knelt in prayer. The Revd McKay read the Catholic service for the dying. When Milner got up to leave, Kellocher affectionately kissed his hand.

The executioner led him forward to the drop, placed the noose around his neck and pulled the cap over his face. The Revd McCorry placed the handkerchief in the condemned man's hand, and instructed him to say "Lord have mercy on my soul" five times. After repeating the invocation the trembling man stood unmoving for a minute or two, then finally dropped the handkerchief. On that signal John Kellocher was, as the cliché of the time had it, "launched into eternity".

His muscular frame struggled convulsively for a time, so the drop had not broken his neck and killed him outright. Soon the jerks stopped, indicating he had finally choked to death. After hanging for around fifty minutes the body was taken down into a coffin and interred in the prison yard. The crowd dispersed peacefully.

Perth Town Council later calculated that the execution had cost them £117 17s 6d.

CHAPTER 9

MURDER FILE №6: JOSEPH BELL

The Blairingone Bread Cart Murder (1865)

It was like a scene from a 1930s black-and-white Hollywood chiller. Out of the fog and gloom of a late December evening emerged a horse pulling a delivery cart, the advertising symbols for William Muirhead & Son, bakers of Alloa, clearly visible on its sides. It was a normal bread run. But the cart seat was empty. And one of the forward wheels, and the side of the cart, was saturated with a dark red fluid.

When it entered the village of Blairingone, the animal stopped at its usual place, waiting for the first customer. When no-one came, it moved on to the second regular stop, outside the shop run by John McDonald. Mr McDonald came out, expecting to greet the driver, John Miller. But where was he? It was just past 5pm, but so dark that McDonald did not see the bloodstains. After about 15 minutes a small crowd had gathered, uneasy at the man's absence. A light was procured and they set off along the road towards Vicar's Bridge, concerned that John Miller had met with an accident. After a few minutes they met two men trying to carry John Miller, who was severely wounded. The pair of labourers were from Downie's Burn farmhouse, and had been alerted by a passer-by named Mrs. Maule who had heard groans coming from the ditch. She had first thought it had been a drunk, but on reflection remembered she had heard a gunshot earlier, and so walked to the farm to give the warning.

A cart was procured and John Miller was taken to John McDonald's house. When Dr John Mitchell Strachan of Dollar arrived, he found two things: almost half of John Miller's face was missing; and the man was conscious, apparently felt no pain, and had no idea what had happened to him.

"What's this that's come over you?" asked Dr Strachan.

"Oh nothing," replied the man, entirely unaware that he had lost an eye and the bones of his skull and jaw were visible through the ruined flesh.

"Does not your head feel sore?"

"No, but I feel a pain in my back."

"Was there any one in the cart with you?"

The modern entrance to Blairingone village. (The Author)

"No – where is the cart?"

Those were the last words he said. He died around 8pm.

John Miller was forty years old, and had been a delivery man for William Muirhead & Son for several years, where he was valued as a reliable and steady employee. For working six twelve-hour days he drew a weekly wage of 15s, on which he supported his wife and two children in his house in Gaberston, near Alloa. On 18 December 1865 he was on his usual Monday run through Clackmannanshire and southeast Perthshire, taking bread to Dollar, Muckart, Vicar's Bridge, Blairingone, Forest Mill, Clackmannan and then home to Alloa, where he would typically hand over the day's takings to his boss around 8pm.

Towards the end of the day, John Miller should have had several pounds in notes and cash on him, plus the pocket-book in which he kept careful note of all the transactions, including the regular customers who owed small sums 'on tick'. A careful search of his pockets turned up just one penny. When the upturned collar of his overcoat was opened, several leaden pellets fell out. More pellets were found in the eye-socket and head wounds. By now it was obvious that John Miller had been murdered with a gun, and for money.

Meanwhile the authorities were already investigating. By the eerie light of a lantern Police Constable George Hossack was pacing the road between Blairingone and Vicar's Bridge, peering through the winter fog. Sometime after midnight, at a point between Mains of Blairingone and the railway viaduct, he found cart tracks and several pools of blood; this was the murder scene. Early next morning Constable

Hossack, accompanied by Procurator-Fiscal McLean and other men, returned to the spot. The blood trail ran along the road for 34 yards, with a major pool at the eastern end and several more at regular intervals. The cart wheels had passed through the pools. At the western end of the trail the wheelmarks doubled back for a short distance, near where the farm labourers had found John Miller. A footprint was found by the ditch on the north side of the road, facing into the road. More footprints, with a distinctive set of 'tackets' or hobnails were traced back 50 yards north through a field to a road that led down to the River Devon, and then from the road towards the river.

The doctor's examination of the body, combined with the analysis of the crime scene, allowed for a reconstruction of the murder. Like some old-time highwayman, the killer had laid in wait on the side of the road, which had relatively little traffic in the depths of winter. The area was lightly populated. No houses or farms overlooked the spot. It was the perfect ambush. When John Miller and his horse and cart slowly paced up the gradient and round the corner, the killer stepped out and fired a shot from between five and ten yards away – it was not further away, as there was no

Approximately the spot where John Miller was murdered. The tree to the right is carved with many initials. (The Author)

The road between Blairingone and Vicar's Bridge is still narrow and quiet. (The Author)

scattering of the shot, and it was not up close as there was no powder burn on the body. Sitting on the cart, the victim's face would have been a couple of feet above the killer's. The shot took John Miller on the right side of his face. The force pushed him to the left, and he slumped over, the blood pouring out of his head onto the left wheel and side of the cart. A shard of Miller's cheekbone was later found in the road. The killer had not been able to both fire and control the horse, and as the cart had trundled along, John Miller's heart had continued pumping blood through his head, each pool on the road marking a heartbeat. The cart had continued for a further 30 yards or so, before the murderer had caught the house's bridle or reins, and caused it to back up a little. The killer had then pulled the driver off his seat, rifled his pockets, and departed north down the slope in the direction of the river, where the trail went cold. (Later a set of long-forgotten stepping-stones were identified as the likely crossing-point.)

There were no witnesses, no definitive clues, and, in theory at least, no suspect. But both police and public suspicion immediately fell on a couple of notorious local ne'er-

do-wells: William Bray (or Brae), described as an English horse-dealer and railway labourer, and Joseph Bell, another Englishman of no fixed abode and a noted poacher. Bill Bray seems to have been quickly discounted (and even turned up as a witness in the trial), but Joseph Bell soon became the suspect of choice.

Every district has its local 'No Good Boyo', the youth or man who is always in conflict with the law, a repeat petty offender and general troublemaker. For the Alloa and Dollar area, that role was amply filled by Joseph Bell. You name it, he'd done it – theft, housebreaking, fraud, dealing in stolen goods, assault, drunkenness, breaches of the peace, poaching and a litany of other offences that had kept the Burgh and Police Courts busy. A few short prison sentences aside, he had escaped major punishment, but was suspected of many more crimes than those he had been convicted of. He was also physically imposing – not very tall, but powerfully built, with a formidable reputation for using his fists. Arresting police officers always made sure they had back-up when taking him to the cells. He had married a shopkeeper in Muckart – which everyone said was a marriage of convenience, her profits being conveniently close to Bell's itchy fingers – but he had not lived with her and their child for some time.

On the night of Wednesday 20 December Bell was arrested at the Tillicoutry home of his friend John Stirling. He was initially held in Alloa on an outstanding charge of defrauding a shoemaker out of a pair of boots and then pawning them for drinking money, but it appears this was a charge of convenience while the main case was built against him. Very soon he was charged with murder. The trial took place in Perth during the Spring Circuit 1866, on April 24 and 25. With extensive local newspaper coverage, the 'Blairingone Murder' guaranteed a packed courtroom. The panel pleaded Not Guilty.

The Crown knew their case was purely circumstantial, and so called over 100 witnesses to painstakingly recreate Joseph Bell's movements and actions in the weeks before the murder, and during the immediate aftermath.

On 7 December William Michie, an engine-keeper at the coal pits at Collyland, close to New Sauchie and Alloa, met a man who said his name was Thomson. At his request Michie loaned him a shotgun, powder flask and caps to the man, on account he returned it within 15 minutes. Bell promptly vanished with the gun and Michie did not see him again until after the arrest (if Michie seemed naïve in lending a gun to a stranger, it was probably unsaid in court that he knew the man was the infamous poacher Joseph Bell, and the *quid pro quo* was that Michie anticipated an illegally-shot pheasant or partridge as payment). Michie identified the weapon. A series of witnesses then described Bell as being possession of the shotgun over the next two weeks, including on the day of the murder. No-one was surprised he had a weapon because everyone knew he was a poacher. On Tuesday the 19th, the day following the crime, Bell told a friend he had had a good day's shooting on the Monday and that as

it was his usual practice to secrete the gun somewhere safe overnight, he had hidden it at Gaberstone, about three miles from Alloa. But on the Wednesday two boys, James Kerr and James Macartney, went to see where the murder had been committed scene (within a few years a nearby tree was covered with the carved initials of visitors to the scene). On the way home to Dollar they stopped for a drink below a bridge about a mile west of Vicar's Bridge – and there, lying in the water, was the murder weapon. When Bell was confronted with the weapon, he suddenly remembered he had left the gun at that spot, and not at Gaberstone.

The footprints at the crime scene were 12¾ inches long and matched the boots Bell was wearing on his arrest, although it seems he had tried to disguise the pattern by having the footwear repaired on the Tuesday. The same prints were found under the bridge arch where the gun was found hidden.

Many witnesses described how in the days before Monday 18 December Bell had no money, and cadged food, drink, powder, shot and accommodation off many of them. None of them seemed to begrudge these gifts, presumably because they were regular beneficiaries of Bell's poaching bounty. Yet on Tuesday 19th Bell was spending freely, and when arrested on Wednesday had in his possession a purse containing £4 17s 6d consisting of paper money (a £1 note), gold (two half sovereigns, equivalent to 10s each), silver (£2 17s 5d) and copper (1d). John Miller's pocket account book – which had been recovered a few hundred yards from the murder scene – showed he should have been carrying £4 15s 7d in monies paid for bread. Miller's widow gave evidence that he was probably also holding somewhere up to £1 in personal cash, in small change. On Tuesday 18th Bell had spent money on drink, on repairing his boots, and had given 1s 6d to a woman he said had bought some game off him before. The prosecution failed to establish the exact sum John Miller had on him, and the exact amount Bell had spent in addition to the money found in his purse, and so the two could not be matched. But what was certain is that on the Monday Joseph Bell was penniless, and on the Tuesday he was flush.

Initially Bell said he had received a loan from Thomas Hogg, a publican and probably a dodgy character who acted as a conduit for Bell's illegal game and monies. But Hogg bore witness that he had never lent the poacher money. Bell then insisted he had shot a number of birds on the Monday, and sold them to a man for £6. However, despite this being a regular customer who owed Bell money from a previous transaction, the poacher did not know his name. Pretty much all the game dealers in the area trooped into court to swear they had never bought birds or animals from Bell, and certainly not on Monday 18 December 1865.

Amid the meticulous paring down of who had what money and how much, and where and when exactly Bell had the shotgun, the most sensational evidence came when Robert Wright took the stand. A weaver from Tillicoutry, Wright admitted to having a problem with drink. On Thursday 8 December he had met Bell for the

first time, and from the following morning to the Sunday night they embarked on a classic 'lost weekend' together, getting drunk in pubs, in lodging houses, and on the road with a band of tinkers. On the Sunday they were walking by Blairingone when Bell said he knew that a man with money came along with a cart on the Kinross road, and if Wright would simply hold the horse's head Bell would "damned soon chuck him". Wright understood this to mean pulling the man off the cart and robbing him with violence, and, horrified, said he may be addicted to drink, but he was not that kind of man. Bell then laughed it off, saying he had suggested it just to test Wright's character. Wright was clearly rattled by the conversation and very early the next morning crept out of their cheap lodging-house, and left without telling Bell. When asked about this, Wright said he felt he had been "too long in his company".

The defence lawyer tried to discredit Wright as an alcoholic fantasist, and pointed out there was no clear correspondence between the money stolen and the money found on Bell. Further, the murder was so sanguinary that the killer should have been covered in blood, yet there was not a speck on his client. (In fact, Miller had leaned so far over when shot that the blood had sprayed away from his clothes, and when Dr Strachan and the constables searched the dead man's pockets, they got no blood on themselves; so it was quite possible for the killer to have avoided any blood contamination.) Bell insisted he had spent the Monday having a 'good shoot' while roving around the countryside, and that the money came to him by his usual occupation, and everything was just coincidence. "I am guilty of shooting a bird or two, but not of shooting at any man," he declared.

The case had occupied over nine hours on 24 April. The following day, after more intensive evidence and an extensive summing up, the jury retired at 2pm. Within twenty-five minutes they returned with a unanimous verdict – Guilty. Lord Ardmillan placed the black cap on his head and sentenced Bell to be fed on bread and water until his execution on 22 May – "And may God Almighty have mercy upon you." Bell, who had appeared unconcerned throughout the trial and remained unmoved by the verdict, promptly replied, "Thank you, my Lord, I am innocent."

During the four weeks he spent as a condemned man in Speygate Prison, Joseph Bell was a subject of intense interest for the prison and religious authorities, and to the press and the public at large. It soon became clear that, had his character been slightly different, he could have achieved some success in life. Physically, he was impressively athletic – if his own account is to be believed, his ordinary walking pace was five and a half miles an hour, he could run a mile in four and a half minutes, and lift half a ton and carry it 60 yards. He had trained many hunting dogs with 'military precision', and had always loved hunting and physical field sports. He was also highly intelligent, with a far greater mental capacity than his relatively limited education in reading, writing and mathematics suggested.

One of his first acts was to fire off a letter complaining about the bread and water diet, setting out how much he was used to eating in England, and enumerating the types of food his energetic constitution demanded. As a result he was switched, not just from the punishment diet, but to a food regime of better quality than that offered to the other prisoners. He kept up a lively correspondence with the prison chaplains and authorities, read a great deal, and composed juvenile poetry. He was also vain, and commissioned a *carte de visite* – a photographic visiting card of the type very popular at the time, usually among the well-to-do. He choose the photograph carefully, finally opting for a pose showing him sitting reading the Bible and displaying his athletic legs. He had eighteen copies made, and distributed them to all the prison warders, and to his friends. He borrowed a watch from a warder for the photography sitting, as he thought it made him look more respectable.

At the time of the verdict Bell was around twenty-eight years old. He had been born to respectable working class parents in the village of St Swadlincote, near Burton-on-Trent, Derbyshire. He had been apprenticed to his father's trade as a potter and moulder, and moved to Scotland when Bell Senior was employed at a pottery in Montrose, Angus. He could keep a tune, sing lustily, and was popular at gatherings. Although he had been faster, better and more organised than any of his workmates, the life of a potter began to pall. Restlessness and boredom gripped Bell. If things had been different he would have been an adventurer, or earned his living in the outdoors, the police or in the army. But instead he moved down, not up. Around the age of nineteen he started drinking heavily and spending time with 'men of low character'. One day he absconded from work, stole money from a colleague, and thus his life of petty crime commenced. Most of the money he made seemed to be spent on drink.

Bell's agent half-heartedly petitioned for a commutation for his sentence, but this was instantly dismissed. One curiosity is that no-one else attempted to intercede on Bell's behalf. It was commonplace at this time for members of the public to get up a petition seeking a lesser sentence than hanging, especially if the murder was a crime of passion, or committed by a woman, young man or first-time offender. But no-one came forward for Joseph Bell. This was probably down to the "foul and premeditated" nature of the crime, as the *Perthshire Advertiser* described it. But there was something else – Bell had no local sympathy. It was probably not just that he was English. When the folk of Alloa and Dollar first heard about the murder, many *immediately* suspected Bell was the perpetrator. It seemed people were happy to buy his illegal game, but nobody actually liked him. It is also likely that many were afraid of the man with the quick temper, powerful physique and eager fists.

In prison, Bell immersed himself in religious tracts. He had emotional reunions with his parents, sister, brother, cousin and uncle (but not his wife). To each of his relatives he handed a small religious book inscribed on the title page with his own poetry. (The

tracts had been purchased by the Revd Mr Milne of the West Church, at Bell's specific request.) Typical of his style was the message to his parents:

Dear Father and Mother, it is the 12th of May,
I wrote these lines for you to-day;
Sad news they will have to tell,
About our parting, Joseph Bell.
In remembrance of me pray keep this book,
With earnest eyes do on it look,
For this day we must take farewell.
Your loving son, Joseph Bell.
But father and mother, don't weep for me
Though on this earth no more you see;
But a better place I'm going to dwell –
Your innocent son, Joseph Bell.

And to his uncle:

I cannot help speaking without amaze;
See how the Court did on the jury gaze;
When the verdict of guilty did sound its knell,
Upon your nephew, Joseph Bell.
Dear uncle, about the jury I must speak again;
But the words won't be the same.
For I have clear conscience, which God can tell
Has your nephew, Joseph Bell.
Dear uncle, it is improper and unsuited
Why didn't the jury do their duty?
But they didn't – and they know it well –
For they sold the life of Joseph Bell.

As the execution approached, Bell gave a letter to the prison chaplain, thanking all the clergy and warders by name – "Instead of being treated as a prisoner, I must say I have been treated as a brother. I hope and sincerely wish that the warders receive a blessing, one and all, from God, on my behalf, who has to die an innocent man."

His protestations of innocence were the hallmark of everything Bell did, said or wrote while in jail. He told his relatives he had lived a bad life, but was innocent of the murder. When one of the jury wrote to him urging a confession – and noting that not one of the jury had even a doubt that he was guilty – Bell dismissed the letter as arrant prejudice. The warders, Magistrates and ministers repeatedly urged him to confess,

but he was adamant. He authorised the Revd J. P. St Clair, the prison chaplain, to print up a post-execution statement that he died an innocent man (this was not published, as St Clair clearly believed Bell was guilty). He asked Dr Barclay, Convenor of the Board of Perth County Prison, to tell his parents that he persisted in proclaiming his innocence to the end.

Around 6am on the morning of the execution morning St Clair tried one last time. (The two men referred to in the letter are Edward William Pritchard, executed in Glasgow on 28 July 1865 for poisoning his wife and mother-in-law; and Franz Muller, who committed the first murder on a British train and was hanged in London on 14 November 1864. Both cases had caught the Victorian imagination and were well known to one and all.)

"My dear Joseph

I am to address you in the room where your portrait was taken, in the presence of the Lord Provost, the Magistrates, and a large company of newspaper reporters, at a little before eight o'clock; and in about ten or fifteen minutes from that time you shall be no more. Now I advise you to confess to the murder open and manfully at the time I close, for the value of your own soul – in peril of everlasting torments. If you have done the deed and you deny it – for the sake of your beloved child, to whom your example of bowing to god would be a great benefit – and for the sake of your uncle, who so manfully defended your life against his own convictions, as he secretly told me. Your doing so would exalt you in the eye of the Christian world far above Pritchard or Muller, who did their deeds with the eyes of their victims openly staring at them."

Revd J. P. St Clair

Bell promptly replied on the back of the letter:

"My dear Sir,

Pritchard confessed to his crime because he was guilty of the crime he was executed for. I do not believe Muller did confess, if so, it must be Muller did the deed. Joseph Bell's going to be executed to-day for a murder that he knows nothing about, and when I speak to-day I shall speak the truth.

Yours truly, Joseph Bell."

Bell had been up since 4am because he had been woken from a sound sleep by the noise of workmen making final touches to the scaffold outside his cell. He took a hearty breakfast, rebuffed another invitation to confess, then carefully arranged his collar and tie. The warders entered his cell and pinioned him, so that his wrists and legs were secure, and he was escorted to a holding room filled with the civic dignitaries

and the gentlemen of the press. Following a religious service he was asked if he wished to say anything. Standing up, he addressed the heavens: "Oh Almighty God! I swear by Almighty God, as I shall have to answer to God, at the great day of judgement, that I will tell the truth, the whole truth and nothing but the truth. Now God knows what I say." He then turned to the assembly. "Now, gentlemen, I am innocent of this murder, as the child unborn. I do not know who committed the murder. I have no idea who did it. I was not me as did it; so for that reason I'm as innocent as a child unborn." He then sat down and stated quietly, "I'm greatly indebted to the ministers for their great kindness and attention given to me. I die an innocent man."

At one minute past eight on Tuesday 22 May the solemn procession moved out onto the scaffold and its adjacent viewing platform. First came the Town Sergeants or High Constables, then Lord Provost Kemp and the Magistrates, followed by Dr Barclay, two policemen, Bell, the Revd St Clair, other ministers, and finally more officials such as the Procurator-Fiscal, the City Chamberlain and the City Architect. The scaffold itself (or "the apparatus" as it was officially known) had been borrowed from Aberdeen, as the seventeen years since the Perth model was last employed had rendered it unfit for use. The Aberdeen device was in good working condition, having last been employed in the despatching of Andrew Brown on 31 January in Montrose.

From the moment on Monday when the scaffold had been erected against the south wall of the Speygate Prison, overlooking the ancient Greyfriars Burial Ground, it had attracted many spectators – in fact, rather more than the crowd of 2000 that turned up to watch the actual execution. Before its final use it stood impressively gloomy, being draped in black for about two or three feet from the top. Barricades had been erected in case the crowd was large or unruly, but even though the streets were filling up from 5am, everything passed quietly, despite a haranguing by Duncan Matheson, a fire-and-brimstone preacher who turned up to lecture any large gathering in Perth. (The Perth authorities, keen not to buck precedent, had asked the Glasgow police, if at Pritchard's hanging, "missionaries" had been allowed to preach near the scaffold; the reply was positive, so Mr. Matheson was allowed to declaim away without interruption.) Many of the audience had walked overnight from Blairingone, Dollar and Alloa. It was a bright, sunny day, a perfect May morning.

The executioner William Calcraft stepped forward. He had been a guest of the city since Sunday night, having travelled first class from London. Assistant Executioner Adam Arthur from Glasgow was also present. Calcraft briskly shook hands with the prisoner, speedily adjusted the noose, and immediately pulled the bolt. At 8.07 Joseph Bell plunged through the drop, his neck broken instantaneously. The crowd dispersed without murmur, while the body swung gently. Around 9am it was lowered onto a bed of shavings and taken into the prison. A request to take a death mask was refused. At noon the remains of Joseph Bell were buried in the prison yard, next to those of John Chisholm and John Kellocher.

The title page of an unauthorised biography from 1846, *The Groans of the Gallows*, supposedly depicting William Calcraft. He was the London executioner for forty-five years. (Author's Collection)

A document in the Perth Council archives demonstrates how bureaucratic a hanging could be – letters and other documents had to be sent out to dozens of individuals and official bodies, the cost of writing and posting each item being carefully noted down by the Town Clerks. In all, the administration costs for the execution of Joseph Bell cost the taxpayer £18 17s 3d. This was just the budget for the paperwork – the fees for the scaffold, executioner, police, soldiers, officials and so on would have been much higher.

CHAPTER 10

ASSAULT AND ARSON

Here we deal with crimes that rank lower than the taking of life. An entire book could be filled with tales of violence against the person or against property, but it would be a rather dull work because of the stereotyped and repetitive nature of the crimes – Man A gets drunk, assaults Man B, or Man C gets drunk and assaults his wife, and so on. The cases highlighted here have all been chosen because they have something unusual about them, or can throw a light on a particular aspect of nineteenth century life.

ASSAULT ON AN EXCISEMAN (1819)

"Murder the villain!" was the cry as fists, sticks and stones rained down on Dugald Cameron. One man smashed a bottle over his head. Another felled him with a spade. Two other assailants tried to break his arms and legs. After he fell unconscious through loss of blood he was tied up, thrown in a cart, and robbed of all his money, documents and possessions. Eventually his broken body was abandoned and he found help, spending eight days in bed before his life was judged to be out of danger.

Cameron's appalling beating came about because he was an Excise Officer. The Government was trying to crack down on the illegal production of whisky – illegal because the unlicensed producers and vendors paid no tax, or excise duty. It was a frustrating war of attrition, with Excise Officers finding that the smugglers often had strong local support, even at the upper levels of society. On 6 March 1819 Officer Cameron entered a bothy in the grounds of Baulk of Struie, a remote hillside dwelling south of Path of Condie and five miles southwest of Dunning. Within, he found a 60-gallon illicit still, including a large copperhead and the spiralling element known as the worm, plus three large mash tubs full of the fermenting liquor called wash, and many empty tuns. It was a major operation. David Barnet of Auchterarder was sitting next to the fire, and escaped with the copperhead and worm as Cameron legally seized

the still. The exciseman had started smashing up the items when Barnet returned in the company of John Brown of Dunning, John Scobie of Newton of Pitcairn and another unnamed man. Together the quartet attacked Cameron.

At one point the bloodied and battered Excise Officer managed to escape and sought help from William Rutherford, a tenant farmer from Whitehill who was ploughing an adjacent field, and Robert Kirk, the shepherd at Middlerig, but the two were driven off by a hail of sticks and stones. When Cameron was recaptured and finally subdued the four assailants paused and realised that if they didn't do something, they might end up with a dead Government officer on their hands, and a future dangling from the end of a noose. They therefore threw Cameron into a barrow and Brown and Barnet took him down the hill to the farm of John Reid at Struie, where nothing could be done for him, as he was now throwing up great quantities of blood. The men pushed on to the pub run by Rollo Kinmont at Pathfoot of Condie. Kinmont, however, refused the injured man admittance to his house and even told Brown and Barnet to drown the exciseman so he would cause no further mischief. The increasingly desperate gang continued down the valley. When two strangers heard groans coming from the barrow the skittish culprits threw Cameron onto the road and skedaddled as fast as possible. It was now 11pm and the injured man had been suffering for several hours. Local assistance was summoned and Cameron was taken to the pub run by Henry Gloag, the vintner in Forgandenny. It was there that Cameron finally received medical attention and recovered.

Barnet and Brown were first brought to trial on tried in Perth on 4 October 1819 but the trial was postponed because John Scobie was in jail in Stirling on a charge of fraud. The Crown had succeeded in 'turning' Scobie and he was to be one of their witnesses. The trial recommenced on 13 January 1820, by which time Scobie had done a runner, so he was outlawed and declared a fugitive from the law. Even without Scobie, Cameron was an impressive witness. The jury took just a few minutes to find both men Guilty.

The Lord Justice Clerk stated that such a serious assault justified transportation, but the court was inclined towards mercy and so sentenced each man to eighteen months in prison, with an additional penalty of a £40 fine if they were in trouble during a probationary period of a further three years. By the standards of the day this was an extraordinarily lenient punishment for a serious assault on a Government officer – on the same round of Circuit Courts, for example, thieves and housebreakers were habitually being sentenced to even or fourteen years' transportation.

At the end of the trial an investigation was ordered into Rollo Kinmont, the refractory publican who had refused succour to the injured exciseman and even suggested his death. If it was shown that he was not a fit person to run a drinking house, he would be deprived of his licence as a vintner and barred from taking up the profession elsewhere.

Six months later the fugitive John Scobie, alias Roger MacLeish, was at the bar in the Autumn Circuit. He confessed to the assault on Cameron, and on 6 September 1820 was sentenced to eighteen months imprisonment. The fourth man involved in the attack was never identified or brought to justice.

COLONEL BULLY (1853 AND 1886)

David Robertson Williamson of Lawers was an Honorary Colonel in the Perthshire Volunteer Militia, a former Lieutenant in the Coldstream Guards, a Justice of the Peace, a Deputy-Lieutenant of the County of Perth, and a major landowner in the Loch Tay area. In other words, he spent his life suffering from a surfeit of toff. He was also a vicious, arrogant bully. In *Shorthorns in Central and Southern Scotland,* a reference work on cattle breeding, the author James Cameron described the Colonel as "A perfect exponent of that 'grand' early Victorian manner…Splendidly athletic in build; spare, handsome, powerfully muscular, lithe in movement…" but also, "very distinctly nasty in his own magnificent manner…an ugly customer with his fists." If that's what Williamson's own social class was saying about him, the Colonel must really have been something of a brute.

The court records back this up. On 13 June 1853 the twenty-three-year-old military man was at the Bar of the High Court of Justiciary in Edinburgh, charged with hamesucken. This was another of the antique names used for certain crimes by the Scottish legal system, and meant entering into a person's home with the intention of assault. Although theoretically a capital crime, in practice by the 1850s it was usually punished with transportation. The victim was the Reverend William Robertson, minister of the united parishes of Monzievaird and Strowan. Williamson gained entry into the study of the manse, lay in wait until the minister returned, and then set about him violently with a stick on his head, arms and back.

At the trial a plea bargain was struck. The Solicitor-General withdrew the charge of hamesucken and Williamson pleaded Guilty to a lesser crime of "assault to the effusion of blood and injury of the person". He was given nine months. For the culprit this was a highly satisfactory result. Firstly, the threat of transportation was removed. Secondly, no witnesses need be called, so the court was silent as to why a distinguished military man and champion boxer would want to ambush and attack a man of the cloth in his own home. And thirdly, Williamson's sojourn in Perth's Speygate Prison was cut short on 14 September 1853, when the High Court in Edinburgh granted a remission of the remaining six months of his sentence. The stink of corruption and the influence of wealth and power is all round the case. If Williamson had been John D. Ordinary, he would have been serving fourteen years in an Antipodean penal colony.

As the local landowner on north Loch Tayside Williamson appears to have been insufferable, blocking up legal rights of way, bullying everyone of a lower social station, and generally being an upper-class bigot. Money can influence behaviour but it can't make people like you. In 1868 Williamson had to flee from a hostile crowd at a polling station, as his brand of politics wasn't exactly to the ordinary person's tastes. Then in 1885, at another General Election, Williamson's temper got him into more trouble.

On 2 November 1885 the Colonel entered a draper's shop in Crieff and requested that the owner spare his assistant Peter McPherson for ten minutes. He then took McPherson into a private room in the Royal Hotel, locked the door, and proceeded the beat seven bells out of the man. The cause of the dispute was a letter McPherson had sent to the *Strathearn Herald* criticising Williamson, who had unsuccessfully stood as an MP. At some point during the election Williamson had called the shop clerk a "bubbly jock" and McPherson had taken umbrage in print. In revenge Williamson demanded that McPherson get on knees and beg his pardon. The younger man refused, and at this point the noise had brought the hotel manager, who demanded admittance, so when the door was opened McPherson fled and further violence was prevented.

The fifty-five-year-old Colonel was tried before the Sheriff Court on the 16 January 1886. He denied everything, including the assault and the whole business with trying to force his victim onto his knees. He claimed the frightened McPherson was "hollering like a Red Indian," and had simply tried to quieten him. Witnesses said they saw something like a struggle from outside the window, but could not make out the details. The hotel manager had not seen any blows actually delivered. It was largely a case of the word of a shop assistant against that of one of the wealthiest and most influential men in the county. The Sheriff found Williamson Guilty of striking one blow on the head, and expressed regret that the only case of violence associated with the General Election in Perthshire had been committed by a gentleman. A fine was imposed of £5. There was the option of imprisonment for a month, but the Colonel decided to cough up what was approximately the cost of a good meal at a high-class restaurant.

ARSON IN ALYTH (1880)

It must have seemed a good idea at the time. Alexander Mitchell, the highly respectable manager of Alyth Gas-Works, boarded the quarter past noon train to Dundee, taking his seat alongside his wife and son. It seemed to be an ordinary family outing, completely innocent and above board. And it was the perfect alibi. But back at his three-storey house on Mill Street things were heating up, and not in the way he had intended.

Around 2am on the following morning, Thursday 8 July 1880, the Mitchells' neighbours were woken by the smell of smoke. Police and local people quickly assembled and broke a window, which allowed access inside so the fire could be extinguished. This prompt action prevented the blaze spreading to not just the adjoining houses, but also the large gas-holder that stood not too far away. Mr. Mitchell was summoned home and arrived back at 1.30pm on Thursday, expressing gratitude that the building had been saved, but then, on searching the house, stating that some money was missing. He thought burglars had got in, created the disorder in the furniture, and then accidentally or deliberately set the place on fire. Within the burned drawers had been about £50 in bank notes and two bank cheques.

But what the manager did not know was that the police already suspected that the fire was not accidental, but a case of arson. And that Mr. Mitchell, the man with a solid alibi, was the chief suspect.

An investigation on the Thursday morning had found two separate origin points for the fire, each amateurishly set. The first was in the parlour on the first floor. It had started on the opposite side of the room from the grate (which had no fire in it at all) and had consumed a chest of drawers and other furniture, as if the items had been the intended target of the blaze. This fire had burned a hole through the flooring and fallen into the ground room, which contained some fuel. Had the fuel caught, the entire house would have gone up. The second fire was even more obvious. Here a hole had been cut into the floorboards of the upper garret and filled with newspapers of recent date. Hard by was a can containing about a gallon of turpentine. Clearly the intention had been for the slow fire to heat up the can, leading to an explosion. The police estimated that the accelerant was within a few minutes of igniting when the fire was extinguished. Clearly Mr. Mitchell had not expected his neighbours to react so fast and so efficiently.

On Thursday evening Alexander Mitchell and his wife Christina, both aged fifty-one, and their twenty-two-year-old son Peter were arrested and charged with wilful fire-raising. Meanwhile the police took possession of the house and the Procurator-Fiscal examined the crime scene.

The case was heard at the Perth Circuit Court on 27 August 1880. Alexander Mitchell probably sacrificed himself for his family – he pleaded Guilty, while Christina's and Peter's pleas of Not Guilty were accepted by the prosecution. The motive for the arson had been to defraud the Scottish Provincial Insurance Company (Aberdeen), with whom the Mitchells had taken out a policy in October 1876. The furniture had been insured for £350, rather higher than its real value. Mitchell had previously been the manager of the Dundee Gasworks and had an exemplary work record, and a certificate of good character from his minister was presented in court. The presiding judge, Lord Craighill commented: "It is a most miserable thing to see a man who had borne your character in your present position. I do not know by

what infatuation you were possessed when you committed the crime…but we must look at the consequences." These consequences being, of course, that the fire could have spread to other houses and beyond. The judge considered a sentence of penal servitude but in the end gave Mitchell eighteen months in Perth Prison.

CHAPTER 11

MURDER FILE №7:
THE MOUNT STEWART MURDER

The Great Unsolved Crime (1866)

Dear Sir,

Please come out here as soon as possible as my sister has been murdered today while I was in Perth.

Your obdt servt,

Wm Henderson
Mount Stewart
Bridge of Earn

That brief telegram commenced the mystery of the Mount Stewart murder, a mystery that still remains unsolved today. After more than a year's investigation, the posting of a substantial reward, and the arrest and release of several suspects, a high-profile court case came no nearer to producing a resolution. In its aftermath came recriminations, personal tragedy and madness.

The communication, dated Friday 30 March 1866, had been dispatched on the 9.20pm North British Railway Company service from Bridge of Earn to Perth, and then delivered to the office of the Procurator-Fiscal. The head 'Fiscal Mr. McLean was away in Pitlochry investigating another case, so at 10.30pm it was taken to the home of the Assistant Procurator-Fiscal, John Young. Within a few hours Young, accompanied by Chief Constable George Gordon, Superintendent McDonald of the County Police, Dr Absolon, Sergeant Ross, and several police constables, arrived at Mount Stewart.

The farmhouse was a substantial structure off the thoroughfare leading from Forgandenny to Bridge of Earn, hidden from the public road by a belt of trees. Apart from a few other rural buildings, none of them particularly close by, it was relatively isolated, the area being thinly populated.

The access road to Mount Stewart; the lonely farm is hidden behind the hill, with no buildings nearby. (The Author)

The facts were quickly established. William Henderson, the tenant farmer, had been at the market in Perth all day. Upon his return around 7pm he found the farmhouse locked and shuttered, which was a surprise as his sister Janet should have been in. William's servant James Crichton said he had not seen the woman since about 11am. Eventually William had taken a ladder and made entry through an unlocked bedroom window on the first floor. He then explored each room, thinking his sister might have been taken ill. On the kitchen floor he found a disordered pile of bedclothes. He put his hand under them and touched a dead body.

William immediately left the house and ran to the home of his nearest neighbour, mason James Barlas, a distance of some 400 yards. The two men returned, lit a candle, and lifted the sheets. It was Janet, lying in a large pool of blood. When William lifted the blankets they were sticking to her head and face with the blood, and he commented, "That speaks for itself". Barlas returned home while William walked into Bridge of Earn and informed a police constable, sent the letter to the Procurator-Fiscal, and met the local physician, Dr. Laing, when he stepped off the train from Edinburgh. At Mount Stewart, the doctor confirmed that life was extinguished, and that it was definitely murder.

Mount Stewart farm. The farmhouse, the murder scene, is in the background. (The Author)

When the proper authorities arrived, William Henderson was taken to a separate room and watched by a constable, while the scene was analysed. This was standard practice, as experience had shown that most murders were committed by family members. And as the first person to discover and report the body, William was doubly suspected.

The eerie light of the candles and police lanterns revealed the extent of the carnage. Janet Henderson had been struck several severe blows with a domestic hatchet, the blood clearly visible on the weapon. The swinging nature of the blows had caused cast-off blood splatter to spray over the walls. The face was a mask of blood. A post-mortem found seven wounds in the skull, one, in the centre of the head, five inches long. The doctors estimated the time of death as probably around 3pm. Although several locks had been forced and draws disturbed, the only items stolen were just over £2 in cash, and some clothes, although William did not miss the latter until a week later. Scattered on the floor were several eggshells, with a half-cooked egg in the ashes of the fireplace. Had Janet been preparing the eggs when she was attacked? Or had the murderer eaten while he was there? The kettle on the kitchen fire was a little warm, and a clay pipe was found. Neither William nor Janet smoked.

Another view of the Mount Stewart farmhouse. (The Author)

Janet Henderson was fifty-one years old, and married to James Rogers, a labourer from Airntully near Stanley. She had several children and was described as strong and muscular. She had arrived at Mount Stewart only on the Wednesday before, having come from her home to do the housekeeping and look after a calving cow. It was a temporary arrangement, designed to tide William over while he looked for a new female servant – the most recent girl had abruptly quit, and William, who had no wife or children, seemed to have a hard time keeping servants.

It was speedily established that William Henderson had a cast-iron alibi for the whole of Friday, with multiple people seeing him in Perth, and then in Bridge of Earn just before he returned home. This left the police without a suspect. Then a Betsy or Betty Reilly, from Meal Vennel in Perth, came forward. Described as "a travelling dealer in stoneware" (or, if the newspapers were being less polite, "an itinerant hawker"), she claimed that early on Friday afternoon she saw Janet Henderson at Mount Stewart speaking to a man who had the appearance of a former man of quality down on his luck. This individual immediately became the prime suspect. His description was printed up on widely distributed handbills:

NOTICE

If any person can give information as to a Man seen on
SATURDAY last, in the Neighbourhood of BRIDGE of EARN,
answering to the annexed description, or if any Person finds
a Large DOOR KEY in that Neighbourhood, they are requested
immediately to inform the PROCURATOR FISCAL at PERTH.

Fiscal's Office, Perth
2nd April 1866

DESCRIPTION
A Man between 40 and 50 years of age
About 5 feet 9 inches in height
Slender make. Thin in figure
Long face. Brown Hair.

DRESS
Dirty Darkish Dress
Wore a Cap.
Dark Frock-Tailed Coat.
Longish Greyish Coloured Trousers.
Shabby Genteel Appearance
Did not look like a Working Man, neither did
he resemble a Hawker or Vagrant.

The bills had an instant effect, all of the wrong kind. A travelling writer who vaguely fitted the description was apprehended in Burntisland and sent on to Perth, where Mrs. Reilly instantly dismissed him. A drover with blood on his clothes was taken in Dundee and brought under police escort to Perth, but his alibi was strong and the blood came from a sheep he had recently slaughtered. A hatter named John Henderson was the next suspect, arrested in Aberdeen. At Perth Betsy Reilly inspected him by gaslight but could not be sure of her identification. The next morning's daylight absolutely positively convinced her that he was indeed the man. Unfortunately further investigation proved Henderson had been on a drunken bender in Edinburgh at the time of the murder. He was released after almost a week in custody, receiving 16s as compensation for wrongful imprisonment, which he complained was not enough. By

this point the police had started to suspect that the hawker was either a liar or the kind of attention-seeking fantasist that murders often attract, and perhaps she had her eye on the substantial £100 reward that had just been posted.

Every development in the case was reported in all three Perth newspapers, as well as in the press of Dundee, Edinburgh and even London. As the days passed and no solid suspect was in sight, wild rumours began to circulate. William Henderson had done it, said many, and so energetic were these stories that James Rogers, the dead woman's widower, published a letter in the *Perthshire Advertiser* defending his brother-in-law: "I can assure the public, who have been listening to many a wild rumour these two weeks past, that there is not the least shadow of suspicion resting on my mind, or on the minds of any of Mr. Henderson's friends, concerning this foul deed." But the constant reporting of the murder fuelled further bizarre anxieties, as described by the *Perthshire Advertiser* on 12 April: "In a house near Perth a man, it was said, had been poisoned by his wife. At Bridgend, a child was believed to have been killed by his father; and in Meal Vennel, no one knows how many murders have been perpetrated within the past week." With no solid information, the case was starting to generate its own urban legends.

By December 1866, almost ten months on from the murder, the investigation had ground to a halt. Then William Henderson intimated to the police that he now suspected the murderer was his former ploughman, James Crichton. A new statement by William's previous servant, Christina Miller, supported the allegation. Crichton had left William's employment shortly after the murder, and was brought from his new job at Dunfermline, and charged with murder. The trial was fixed for the Spring Circuit at Perth, on 9 April 1867.

The investigation of a murder, by its very nature, fixes an unforgiving glare on all those who are touched by it, whether victims, alleged perpetrators, or acquaintances and relatives of the deceased. Relationships, character and behaviours are mercilessly exposed. William Henderson had asked his sister to help out because yet another of his female servants had quit, the fourth or fifth in recent times. Everyone knew it was because the fifty-three-year-old bachelor kept trying to take advantage of them. The last to leave, Christina Miller, departed after less than two weeks because of William's attentions. As she stated in court, "He was always wanting into me after I was in my bed. I locked Henderson into one of his rooms once for a great part of the day. I took up the tongs to him once or twice." Male farmworkers also did not last long, probably because William was miserly with his wages and his supplies of food. It was well known that William did not like Crichton, and he seems to have not told the ploughman that Janet was his sister – it was as if he was hoping Crichton, thinking Janet to be another servant, would speak his mind indiscreetly. When William attempted to gain entry on the night of the murder, he found the kitchen door locked and the key missing. Several months later he 'found' the key in a cesspool, and suggested that only Crichton could

have put it there. Crichton, in his turn, had told several witnesses he thought William had both the time and the opportunity to have murdered Janet.

The case against Crichton was slim indeed. He told many people he did not smoke, but many witnesses had seen him puff at a pipe. After the date of the murder he seemed to have a new pipe – remember, an anomalous pipe was found in the Mount Stewart kitchen. Some witnesses thought he might have changed his clothes during the Friday, being dressed in dark colours in the morning and white garments later on. Further, his other set of clothes were seen bleached and cleaned outside his house. All this was suspicious because the person who killed Janet Henderson must have been covered in bloodstains. There was a vague attempt to show that the Crichtons had some additional money that could only have come from the robbery. Other witnesses claimed he seemed unconcerned at the murder, and mentioned his attempts to implicate his master.

The key evidence came from Christina Miller, William's former servant. After she quit (at the start of the week before Janet was killed) she left a trunk with the ploughman and came back to claim it a short time after the murder. While sleeping in their house she said she heard Crichton and his wife speaking about the murder around the fireside. According to her testimony, James Crichton said "If it was found out that he was the murderer he would be hanged for it," to which his wife responded "What will become of me and the family if you are hanged for it?" A similar conversation was apparently repeated late the following night, and Crichton's wife warned her husband to guard his words around Christina, lest she pick up something to use against him. Christina also claimed to have seen two pound notes in the hands of Crichton's wife (£2 and some silver was known to have been taken from the farmhouse).

The key problems with this farrago were that (a) Christina waited several months before revealing the results of her eavesdropping (b) she was held in Perth Prison to make sure she did not skip before the trial, because the prosecution was deeply uneasy about her character and motivation and (c) for a poor servant earning a few shillings a week, a reward of £100 is a powerful incentive to lie.

Clearly the jury didn't believe her. After two days of testimony they retired for just ten minutes and returned with a majority verdict: Not Proven. The prisoner was accordingly released.

The aftermath was devastating for William Henderson. He could no longer stand to live at Mount Stewart and by January 1867 had given up his tenancy, and indeed the farming life altogether. He accused two of the witnesses called by the defence of having committed perjury, and was quickly hit with a slander suit. James Ritchie, a labourer on the adjacent farm of Dumbouls, provided testimony that suggested James Crichton had not had enough time to complete his ploughing and get to Mount Stewart farmhouse to commit the murder. Ritchie sued for £12 and at the end of April 1867 was awarded damages of 30 shillings, the sum being so low because the judge

sympathised with William's distress and loss. Three years later William had the legacy from a wealthy uncle cut in half for some unspecified reason, possibly a moral lapse (did William still have an eye for servant girls?). Or perhaps it was because his mind was already going.

In 1881 spent he three months at the Murray Royal Asylum "in a state of Mental Derangement". As well as rambling incoherently and ranting about being poisoned or eviscerated, he made constant references to Janet, her death, and the key. It appeared that the murder – now fifteen years in the past – had consumed his mind, a situation made worse by his solitary and brooding habits. Eighteen months after his release he was found on the streets still raving about the murder. In 1884 he went on a window-smashing spree and was admitted to the asylum in a terrible physical state and covered with body lice. He remained at Murray Royal for the last six years of his life, and died there in January 1890, aged seventy-seven. An analysis of his estate showed that, had be retained his sanity, he had had enough money to enjoy a very comfortable retirement.

The Mount Stewart murder destroyed William Henderson, making him its secondary victim. The primary victim, Janet Henderson, bludgeoned to death in her brother's kitchen, has never received justice.

CHAPTER 12

MURDER FILE № 8: GEORGE CHALMERS

The Braco Murder (1869)

The Capital Punishment Amendment Act of 1868 ended the days of public hangings. From now on, all executions were to take place within the walls of prisons, hidden from the eyes of the populace, the proceedings governed by precise protocol. The move was largely prompted by the disquiet over the behaviour of the crowds at public hangings – a recent execution in London had prompted scenes of drunken disruption, jeers, and violence. From 1868 the only spectators were to be the prison and civic officials, and the press.

The new Act was not long in finding a customer. On 4 October 1870 George Chalmers became the first person in Scotland to be hanged within prison walls. He had been sentenced for what had become known as the Braco Murder.

John Miller was a harmless old man who worked as the tollkeeper at the Blackhill Toll Bar, just where the road to Dalginross and Comrie branches off the Braco-Crieff road. The old tollhouse still stands on the north side of the B827. Sixty-four years old, unmarried, and of solitary habits, Miller had been the tollkeeper for five years. The quiet life suited him, as he was in delicate health and walked with a stick. He knitted socks, patched his clothes, played draughts with his friends, and collected the tolls from passing vehicles and riders. In his sober way, he had saved a bit of money, which was mostly kept in bank. Other than the murderer, the last person to see John Miller alive was shepherd Walter Mclaren, who passed by about 8pm on Tuesday 21 December 1869. John said he was not intending to go to bed late, but he was half expecting his other friend Archibald McLaren to call in later, so he did not lock the door behind Walter. Indeed, the old man usually kept his door unlocked until he retired for the night, which was typically around 10pm. As it turned out Archibald took an alternative route home from his work as a miller; if he had called at Blackhill as anticipated, things might have been very different.

Around 6.30am on the following frosty morning Archibald McLaren and farm servant Peter McLeish found the tollhouse locked and shuttered. Fearing that John

The former Blackhill Tollhouse, now extended. (The Author)

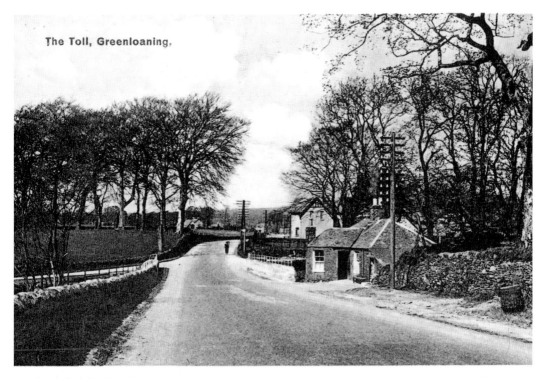

The Tollhouse at Greenloaning, about three miles from Braco. The Blackhill Tollhouse would have looked virtually the same. (Author's Collection)

Miller may have had an accident, the miller went to Ardoch, about a mile away, and brought back John's sister Mary. With her permission he cut a pane out of a window and forced open the shutters with a hatchet. The tiny house consisted of two main rooms, with an entry lobby. In the west room, left off the lobby, was the prone body of John Miller, his head and shoulders covered with a mask of congealed blood.

The police, led by Peter Stuart, Superintendent at Dunblane, arrived by mid morning and conducted a minute examination of the crime scene. The initial facts were quite plain. The tollkeeper had been struck down by a heavy blow on the right forehead, completely smashing the rim of his small felt hat, and then hit twice more with great force as he lay on the ground. The murder weapon was a crowbar found next to the body, with blood and hair stick sticking to it. There was no sign of a struggle or forced entry. The post mortem suggested John Miller had lived for some time after the attack.

The reconstruction of the events suggested the killing had taken place between 9 and 10pm on Tuesday. Footprints were found leading from the front of the house to a closet window at the rear, which had a clear view through to the west room. From this vantage point the murderer had watched while the old man had started to prepare his supper of bread, cheese, ham and porter. The killer had then rushed in through the unlocked front door, knocked the seated Miller to the ground, and finished him off with two more brutal blows as the frail man lay face up on the floor. A silver watch and chain was then snatched from his waistcoat, and the room ransacked of available cash, amounting to around 20 shillings. The killer had then left by the front door, locking it behind him and throwing the key into the garden, where it was later found after a thorough search. It appeared John Miller had fallen victim to a classic murder-robbery, the vicious crime carried out with coolness and efficiency.

Initial enquiries established that three tramps had been seen passing through the area on the night of the murder. Less than 12 hours after the police arrived at the murder scene, two of the men were apprehended in Crieff, and a short while later the third was taken in Comrie. All three were brought to Dunblane Prison, where they were judicially examined on the Thursday, 23 December. Hopes of a quick solution to the crime faded during the questioning, and within a couple of days all three tramps were released. Police enquiries continued but they had no suspect.

One of the curiosities of the case was that the most valuable evidence only turned up a week after the killing. Mary Miller found that her brother's effects were missing a suit of tweed clothes, a red and black shirt and a pair of boots. On 29 December Constable William Morgan and Superintendent Stuart searched the east room (the one opposite the murder scene) and found a blood-spotted coat, shirt and trousers hidden away behind a large pile of firewood. It was obvious that the killer had left his old clothes behind, and their condition suggested he was a vagrant. Within the pockets were a knife, awl, scissors, watch-key, button, hairpin, tobacco pipe and two pipe

heads. A ragged waistcoat had previously been found in the west room, its pockets busy with needles, broken fish-hooks, gut, a pawn-ticket and a toothcomb. A cap, stockings and old boots had also been unearthed, none of which had belonged to John Miller. All of these items were later to prove crucial to the case.

In mid-January the police got the breakthrough they were looking for. The clothes found discarded in the tollhouse were identified as a match to those worn by George Chalmers, a vagrant who had been released from Alloa Prison on Monday 20 December, the day before the murder. Earlier in the month Chalmers had got drunk and exposed himself in the town; he was sentenced to ten days' imprisonment for disorderly conduct. He was itinerant, and had been a regular guest in various bridewells and lock-ups. On 18 January 1870 description was issued and widely distributed to police forces throughout Scotland and England. An official reward of £50 was posted.

For four months there were no results. Towards the end of April two tramps fitting the description were apprehended at different ends of the country, one in Kenmore by Loch Tay in Perthshire, and the other, a Mr. Macgregor, in the Yorkshire town of Rotherham. But both were soon released without charge. The Braco Murderer remained at large.

Then a uniformed police officer on duty in Dundee's Princes Street stopped a vagrant around 2am on the morning of Saturday 14 May. Constable Edward Billington asked the tramp where he was heading, to which the man replied Aberdeen, via Arbroath. After a short chat he went on his way. A little later the constable reported the incident to his sergeant, and realised the man he had spoken to answered the description of the much-wanted Chalmers. A sweep of the streets found nothing. At 6am Billington came off duty, but instead of heading to bed he changed into his civvies and set off along the eastward route the tramp said he was taking. He found the man carrying a sack of guano near the farm of Claypotts, on the Broughty Ferry Road. The suspect gave his name as Andrew Brown; when told he was being arrested for the murder of John Miller his reply was, "Na, na, there have been a few taken up for that already, you'll need to let me awa' also."

Constable Billington took the man to Broughty Ferry railway station, and by 11am they were in Dundee Police Station. At first the man stuck to the story that he was Andrew Brown, and claimed he had never been in Alloa Prison. But then his story changed: he admitted he was Chalmers, and that he had been in jail in Alloa, also somewhere in Wales, and a few other places. He said he earned his living wherever he could – at one point he had shipped on a whaler, other times he fed cattle, and when he had no money he sang and begged in the streets. As well as 'Andrew Brown', he also used the name James Wilson as an alias. He utterly denied being the murderer.

Chalmers was detained in Dunblane Prison, to where a number of witnesses from Alloa and Braco were brought in the hope that they could identify him. When arrested

Chalmers was not wearing any of the garb stolen from the tollhouse, so it was essential to prove (a) that he had been seen at Braco and (b) that he had been seen wearing the old clothes left behind at the murder scene.

The case took a tangent at one point when a Detective Wilson travelled from Glasgow to see if Chalmers could have been the perpetrator of an appalling rape-murder in the city's Stockwell Street. The victim was a five-year-old girl, Margaret Burns, whose mutilated body was found on 18 April 1870. Around thirty different men had been apprehended for the crime and then released. The description of the assailant, given by a boy and girl living on the street, closely matched that of George Chalmers, and the two witnesses were brought to Dunblane to confront the man in custody. They afterwards stated that, of all the suspects they had been shown, Chalmers most closely resembled the red-whiskered man they had seen on the night in question. The detective, however, was unconvinced, and further enquiries eliminated Chalmers as a suspect. The Stockwell Street murder was never solved.

George Chalmers was brought to the Autumn Circuit Court at Perth on 7 September 1870. The prosecution case had two key elements: a series of witnesses who traced the route of Chalmers from Alloa on the Monday morning to Stirling that night, then on the following day via Whitestone and Greenloaning to Braco in the evening; and the identification of the clothes and items found at the murder scene as all belonging to Chalmers. Although some of the witnesses were a bit vague as whether the man they had seen was actually Chalmers, others positively identified his distinctive features – his height (five feet five inches) his slouch, and his stammer. At some point during the two days he was seen travelling and begging with another, taller man, who seems never to have been found.

But it was the clothing and items found at the murder scene that proved conclusive. Sergeant Archibald Carmichael, and former Sergeant Samuel Ferguson and former Constable John Robertson, all of Alloa Police, either positively identified the clothes and bric-à-brac as being in Chalmer's possession when he had been arrested in December, or said they resembled his property. William Wallace, the Warder at Alloa Prison, testified that he had removed Chalmers clothes and property when he was admitted, and identified some but not all of them in court. All four men remembered the awl and pawn ticket, and two recalled the knife and fishhooks and gut. Most could identify Chalmers' cap and jacket. Some of the items were also identified in court by Mary McFarlane, wife of the keeper of the County Buildings at Alloa, while John Haldon, manager of the *Alloa Journal*, had seen Chalmers during his trial for disorderly behaviour in December, and he was then wearing the jacket and trousers found hidden behind John Miller's lumber pile.

Chalmers was given an unprepossessing description by the reporter of the *Perthshire Courier* – reddish-brown hair and whiskers, rounded shoulders, a flat broad face and low forehead, small sunken eyes, thick lips, and an inane expression. He was around

forty-five years old, of no fixed abode, and came from Fraserburgh in Aberdeenshire. He seemed to be bored with the proceedings, and did not follow the evidence. Several people who had met him thought he was 'simple'. He claimed the clothes found at the tollhouse had been taken from him either when he left Alloa Prison, or shortly after. His testimony was that he had never been in Braco, and after his release from Alloa had walked from Stirling to Edinburgh where he stayed until the New Year, before wandering via Glasgow to Newcastle and a job droving cattle in Northumberland. After that he had tramped around Cumberland and Westmoreland and then headed back to Scotland via Carlisle, stopping at Glasgow, Stirling and then Dundee, where he had been arrested. The defence called witnesses who thought they had seen Chalmers at Linlithgow, but were vague about the dates. The entry books of the Night Asylum at Edinburgh showed an entry for Andrew Brown, one of Chalmers' aliases. If he had been at the shelter on the night in question, Wednesday 22 December, he could not have committed the murder. However, no evidence was produced to support any other part of the tramp's story.

After a day and a half of evidence in a packed courtroom, the jury retired at 2.15pm and returned about forty-five minutes later. The *Perthshire Courier* reporter clearly had a sense of the dramatic, and described the scene thus:

> The Clerk said – Gentlemen, have you agreed upon your verdict?
> The Foreman (Mr Jamieson, bleacher, Kirkcaldy) – We have.
> The Clerk – What is it?
> The Foreman (amid profound silence) – The jury, by a majority, find the prisoner, George Chalmers,
>
> <div align="right">GUILTY AS LIBELLED.</div>

When the Lord Justice-Clerk sentenced Chalmers to be hanged, the man in the dock burst into tears and almost drowned out the judge's words.

The change in the law regarding executions now specified that the condemned felon was to be kept in prison for three weeks following the sentence (each week marked by a Sunday), and then hanged at 8am on the first Monday thereafter. George Chalmers spent his time listening to religious instruction, enjoying his food and sleep, and endlessly accusing the police and jailors of Alloa as having perjured themselves in court. He was well-behaved and generally quiet and uncommunicative, but had an emotional and tear-filled meeting with his two brothers and his brother-in-law, at which he admitted to having led a deeply sinful life, but denying he had committed the murder.

Meanwhile in Chalmers' home town of Fraserburgh frantic efforts were being made to stave off the execution. The Revd McLaren forwarded two petitions of two to three hundred signatures apiece to the Home Secretary. One claimed the evidence against

Chalmers was insufficiently conclusive to justify execution, while the other pleaded for mercy on account of the prisoner's "defective mental condition". On Monday 3 October the reverend gentleman received a reply from the Under-Secretary of State stating that a review of the case had uncovered no reason for the decision to be changed.

The petitions and review had delayed the execution by twenty-four hours. At 7am on Tuesday 4 October 1870 the Lord Provost and Magistrates of Perth gathered in the Town Hall and walked in procession the mile or so to the prison. Within the prison gate they were met by Sheriff Barclay, who solemnly handed the death warrant to the Lord Provost. Just after 7.30 the party of thirty officials and reporters went to Chalmers' cell, and at the open door they all sang a hymn popular at Church of Scotland services. The Revd St Clair then read a passage from the 51st Psalm, a well-known lament that starts:

Have mercy upon me, O God, according to thy loving kindness: according unto the multitude of thy tender mercies blot out my transgressions.
Wash me thoroughly from mine iniquity, and cleanse me from my sin.
For I acknowledge my transgressions: and my sin is ever before me.

The Lord Provost entered the cell and asked Chalmers if he had anything to say. The condemned man merely asked that a letter be delivered to his sister in Peterhead and the text published in the newspapers. The Revd Fleming then addressed the prisoner in such an extraordinary way that his speech is worth repeating in full:

"It is my duty, as a minister, to tell you that, sin unconfessed, we have reason to believe, is sin unpardoned and unforgiven; and those who are guilty of it expose themselves to everlasting ruin. And if you go into the eternity that is before you with a lie upon your lips, we have reason to fear that you are now on the brink of ruin, on the verge of the bottomless pit; and I therefore ask you, in the sight of God, to relieve us from the very distressing position in which we are now placed, and to say whether or not you are guilty of the awful crime for which you are now about to suffer; because, remember you are about to enter into the great eternity."

In other words, (1) George Chalmers was about to go to Hell because he had not confessed his crime and (2) if he confessed now, not only would he save his soul but the authorities would not be embarrassed by the lingering doubt that they were going to execute a man for a crime he may not have committed. Fleming finished by saying, "As you value your salvation, answer truly." Chalmers' response was, "No sir, I am innocent. I was not there at all. That is all I can say."

The religious formalities having been dispensed with, the executioner William Calcraft entered the cell and pinioned the prisoner. Chalmers was calmness personified,

even helping the hangman tighten one of the straps. Things now proceeded briskly, with Chalmers, a jaunty spring in his step, quickly escorted onto the scaffold close to the east wall. Two timbers sprang upright from the platform, supporting a horizontal beam from which hung the noose. The entire operation was shielded from the other prison buildings and any windows. In the distance could be heard the bell of St John's Church, which had been tolling mournfully since 7.45. When asked by the executioner if he was guilty, Chalmers replied, "No, I know nothing about it. I will die like a man for it, yes I will. Lord have mercy on me." The white cap was fitted over his head. With his last breath, he addressed the official party in a clear voice: "Goodbye to you all for ever more. I'm quite innocent – may God have mercy on me."

William Calcraft pulled the bolt, the trap door opened, and at 8.08am George Chalmers was launched into eternity. A black flag was run up the jail's flagpole. Like the tolling of the bell – which continued for a further 15 minutes after the execution – this was an innovation, introduced as part of the new execution regime. The body was allowed to hang for 40 minutes, but was hidden from sight by the screen covering the bottom of the scaffold. The corpse was placed into a coffin and at an unmarked spot buried in the prison grounds.

Small groups had begun to gather outside the prison from 7am, and by 8 there were around 200 present. When they saw the flag ascend the flagpole they quietly dispersed. The contrast with the semi-carnival atmosphere of public executions could not be more marked.

Several newspapers reproduced Chalmers' last letter to his sister. As the tramp could barely read, he obviously had some help composing it, and it is hard to imagine a semi-illiterate vagrant using words such as 'profligate' or 'melancholy'. The sentiments about the evils of drink also sound like the suggestions of a pious and moral interlocutor.

Perth Prison 3d October 1870

My Dear Sister –

I received both your letters; the first was read to me by the Governor of the Prison, and the last one by Sheriff Barclay, and O! I felt very sad when listening to your kind and faithful words, while tears ran down my cheeks as I know they are the last letters I will get from you. I confess with sorrow that I have been a most wicked man for the last twelve years. I disobeyed all the good counsel of our dear father and mother.

I left my home and took to a wandering life which led me into every kind of evil company, and which I do now most bitterly regret.

O, my dear sister, strong drink has been my ruin; it has been the cause of all my troubles. O that I had taken your many advices, and kept free from that accursed drink; it has brought thousands of men and women to shame and misery, and so it has brought me. I now see the folly of all my sinful ways, and what my reckless life has brought me to.

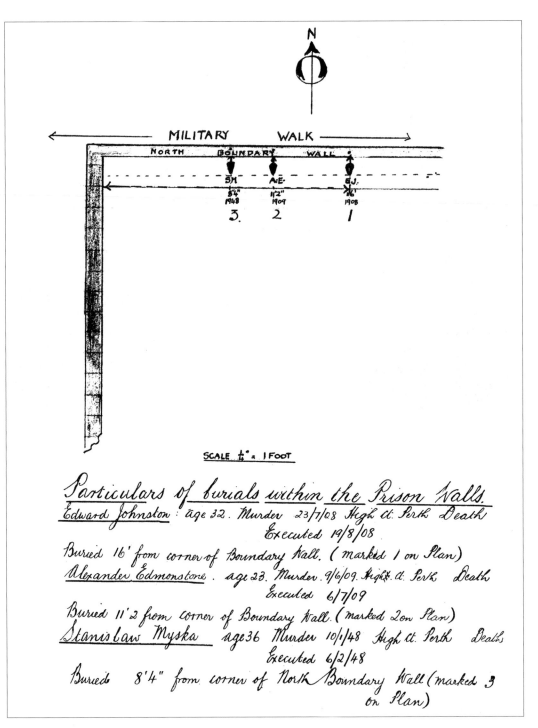

The grave sites of the three men hanged in Perth Prison in the twentieth century. There is no record of George Chalmers' grave, but he was probably buried near here, against the north prison wall. (Courtesy of Wayne Stevenson)

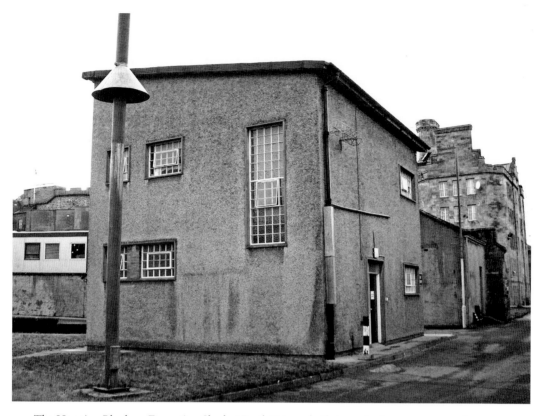

The Hanging Block or Execution Shed at Perth Prison, built in 1965. It was never used. (Wayne Stevenson)

I feel thankful to the Rev. Mr Fleming, the Rev. Dr Manson, Sheriff Barclay, and also the Chaplain of the Prison for all their Christian labours on my behalf.

I have also to thank the Governor of the Prison, as well as the other prison officers, for their uniform kindness to me while here.

My dear sister, I wish you would allow this letter to be made public after my death for the benefit of my fellow-creatures, that they may take warning from my sinful and profligate life, and its melancholy end.

So farewell, my dear sister, while I remain your loving but unfortunate brother,

(Signed)

GEORGE CHALMERS

Joseph Sime, witness

Andrew Syme, wtness

P.S. – I must add my thanks to my counsel and agents who did all they could for me.

(Signed) GEORGE CHALMERS

On 5 October Police Constable Edward Billington received the £50 reward for apprehending the Braco Murderer.

Four years previously William Calcraft had hanged Joseph Bell in Perth. The Chalmers hanging was the veteran executioner's last job in Scotland, and the last execution that took place in Perth in the nineteenth century. There were single hangings in 1908 and 1909, and in 1948 murderer Stanislaw Myszka became the last person ever to suffer capital punishment in Perth.

In 1965 a purpose-built Hanging Block or Execution Shed was completed at Perth Prison. It was never used, as what turned out to be the final hanging in Britain had taken place the previous year. Capital punishment for murder was abolished in 1965. The Execution Shed could have theoretically still been used for persons found guilty of treason or piracy with violence, but those two crimes ceased to be capital offences for civilians in 1998. As of 2004, the UK abolished the death penalty entirely for both civilians and members of the military under all circumstances, including in times of war. The Perth Hanging Block was demolished in the 1990s.

BIBLIOGRAPHY

BOOKS

Anon. *Guide to the City and County of Perth* (no publisher; 1822)

Adams, Norman *Scotland's Chronicles of Blood* (Robert Hale; London, 1996)

—*Scottish Bodysnatchers: True Accounts* (Goblinshead; Musselburgh, 2002)

Cameron, James *Shorthorns in Central and Southern Scotland* (William Blackwood & Sons; Edinburgh and London, 1921)

Cameron, Joy *Prisons and Punishment in Scotland from the Middle Ages to the Present* (Canongate; Edinburgh, 1983)

Cant, James et al *Memorabilia of the City of Perth* (William Morison; Perth, 1805)

Cockburn, Lord *Circuit Journeys* (David Douglas; Edinburgh, 1889)

Haynes, Nick *Perth & Kinross an illustrated architectural guide* (The Rutland Press; Edinburgh, 2000)

Holder, Geoff *The Guide to Mysterious Perthshire* (Tempus; Stroud, 2006)

—*Scottish Bodysnatchers: A Gazetteer* (The History Press; Stroud, 2010)

Livingstone, Sheila *Confess and Be Hanged: Scottish Crime & Punishment Through the Ages* (Birlinn; Edinburgh, 2000)

The New Statistical Account Volume X: Perth (William Blackwood; Edinburgh and London, 1845)

Penny, George *Traditions of Perth* (Dewar, Sidey, Morison, Peat and Drummond; Perth, 1836 – reprinted Wm Culross & Son; Coupar Angus, 1986)

Ramsey, Ted *Don't Walk Down College Street* (Ramshorn; Glasgow, 1985)

Sievwright, William *Historical Sketch of the General Prison of Scotland, at Perth* (Alexander Wright; Perth, 1894)

Tod, Thomas M. *The Scots Black Kalendar: A Record of Criminal Trials and Executions in Scotland 1800–1900* (Munro & Scott; Perth, 1938)

Young, Alex F. *The Encyclopaedia of Scottish Executions 1750 to 1963* (Eric Dibby Publishing; Orpington, 1998)

BROADSIDES IN THE NATIONAL LIBRARY OF SCOTLAND

"The Last Speech Confession and Dying Words of Donald M'Craw" (1795) – shelfmark: 6.365(098)
"Murder of a young woman in Ballinlick" (1799) – shelfmark: 6.365(099)
"Atrocious Case of MURDER and THEFT" (1824) – shelfmark: F.3.a.14(8)
"The trial and sentence of Margaret Boag" (1824) – shelfmark: Ry.III.a.2(51)
"The proceedings of the Circuit Court of Justiciary, Perth" (1833) – shelfmark: F.3.a.13(87)

NEWSPAPERS AND MAGAZINES

Chapter 1. Margaret Boag: *The Aberdeen Journal* 6 August 1823; *Caledonian Mercury* 22 January 1824; *The Morning Chronicle* 24 January 1824; *Perthshire Courier* 23 January 1824.

Chapter 2. Duncan Clark: *The Aberdeen Journal* 1 November 1826; *Caledonian Mercury* 16 October 1826; 2 May 2 1827; *Glasgow Herald* 25 September 1826; *Perthshire Courier* 21 September 1826.

Chapter 3. Prison Tales: *Perthshire Advertiser* 3 September 1835; *Perthshire Courier* 2 April 1824; 5 June 1834; 23 December 1862; *The Scots Magazine* Volume 79, 1817.

Chapter 4. Invasion of the Bodysnatchers: *Caledonian Mercury* 30 October 1820; *Perthshire Courier* 11 March 1829; 9 April 1829.

Chapter 5. The Wife Killers: Donald McCraw – *Morning Post and Fashionable World* 5 October 1795. John Stewart (1824) – *The Aberdeen Journal* 12 May 1824; *Caledonian Mercury* 23 September 1824; *The Morning Chronicle* 28 October 1824; *Perthshire Courier* 17 September 1824; *The Scots Magazine* Volume 15, 1824. John Chisholm – *Caledonian Mercury* 8 October 1832; *The Morning Chronicle* 6 November 1832; *Perthshire Courier* 4 October 1832. John Stewart (1833) – *Perthshire Courier* 4 October 1832; 18 April 1833. John Young – *Glasgow Herald* 20 January 1886; *Perthshire Courier* 26 January 1886.

Chapter 6. "To be hanged by the neck until he be dead…": *Caledonian Mercury* 9 January 1817; 23 January 1817; 21 April 1817; *Perthshire Courier* 25 September 1817; 6 November 1817; 11 May 1820; 22 June 1820; *The Scots Magazine* Volume 79, 1817.

Chapter 7. Deaths in the Family: James Gow – *The Aberdeen Journal* 6 October 1800; *Caledonian Mercury* 15 May 1800; *The Scots Magazine* September 1800. Pierce Hoskins – *Perthshire Courier* 23 April 1812; *The Scots Magazine* Volume 74, 1812. Janet Stewart – *The Aberdeen Journal* 17 October 1832; *Perthshire Courier* 11 October 1832. James McCabe and Thomas Ryder – *Perthshire Advertiser* 23 April 1886; *Perthshire Courier* 23 March 1886.

Chapter 8. John Kellocher: *Caledonian Mercury* 7 May 1849; 31 May 1849; *Glasgow Herald* 1 June 1849.

Chapter 9. Joseph Bell: *Perthshire Advertiser* 21 December 1865; 26 April 1866; 3 May 1866; 24 May 1866.

Chapter 10. Assault and Arson: *Aberdeen Weekly Journal* 12 July 1880; October 9, 1880; *Blairgowrie Advertiser* 10 July 1880; 9 October 1880; *Caledonian Mercury* 11 October 1819; 13 January 1820; *Glasgow Herald* 25 December 1880; 29 December 1880; *Lloyd's Weekly Newspaper* 19 June 1853; *Perthshire Advertiser* 2 September 1880; *Perthshire Courier* 13 January 1820; 19 January 1886.

Chapter 11. The Mount Stewart Murder: *Dundee Advertiser* 3 April 1866; *The Dunningite* Newsletter 62, Winter 2007/08; *Perthshire Advertiser* 5 April 1866; 12 April 1866; 19 April 1866; 26 April 1866; *Perthshire Courier* 3 April 1866; 24 April 1866; 22 May 1866; 29 May 1866; 30 April 1867; *Perthshire Journal and Constitutional* 5 April 1866; 19 April 1866; 27 December 1866; 10 January 1867; 11 April 1867; *The Scotsman* 2 April 1866; 20 December 1866.

Chapter 12. George Chalmers: *The Aberdeen Journal* 28 September 28 1870; 12 October 1870; *The Derby Mercury* 12 October 1870; *Glasgow Herald* 25 December 1869; 28 December 1869; 18 January 1870; 19 April 1870; 16 May 1870; 17 May 1870; 18 May 1870; 20 May 1870; 4 October 1870; 8 October 1870; 9 November 1870. *Liverpool Mercury* 25 April 1870; *Lloyd's Weekly Newspaper* 9 October 1870; *The Newcastle Courant* 27 May 1870; *The Pall Mall Gazette* 7 October 1870; *Perthshire Courier* 13 September 1870; 4 October 1870.

ACKNOWLEDGEMENTS

I would like to especially thank the staff of the splendid A. K. Bell Library in Perth, particularly Sara Ann Kelly, Marjorie Donald, Yvonne Bell and Anne Carroll, all of the Local Studies Department, for their dedication, knowledge and enthusiasm – not to mention resisting the urge to run and hide when I turn up with another sackload of strange requests. Further thanks are due to the staff of the Perth and Kinross Council Archives, Simon Warren of the Dunning Parish Historical Society, and Wayne Stevenson of Perth Prison.

Especial thanks to Ségolène Dupuy for services above and beyond.

For more information on Geoff Holder's books on mysteries, the paranormal, and matters strange and Fortean, please see www.geoffholder.co.uk.

INDEX

PLACES – PERTH

PLACES – PERTHSHIRE

PLACES - ELSEWHERE

KILLERS, CONVICTED AND ALLEGED

OTHER CRIMINALS, CONVICTED AND ALLEGED

HOMICIDE VICTIMS

OTHER PERSONS

CRIMES

PUNISHMENTS

ALSO AVAILABLE FROM
AMBERLEY PUBLISHING

THE JACOBITES AND
THE SUPERNATURAL

Geoff Holder

Price: £12.99
ISBN: 978-1-84868-588-8
Binding: PB
Extent: 128 pages